Watercolor Basics:
Painting Flowers

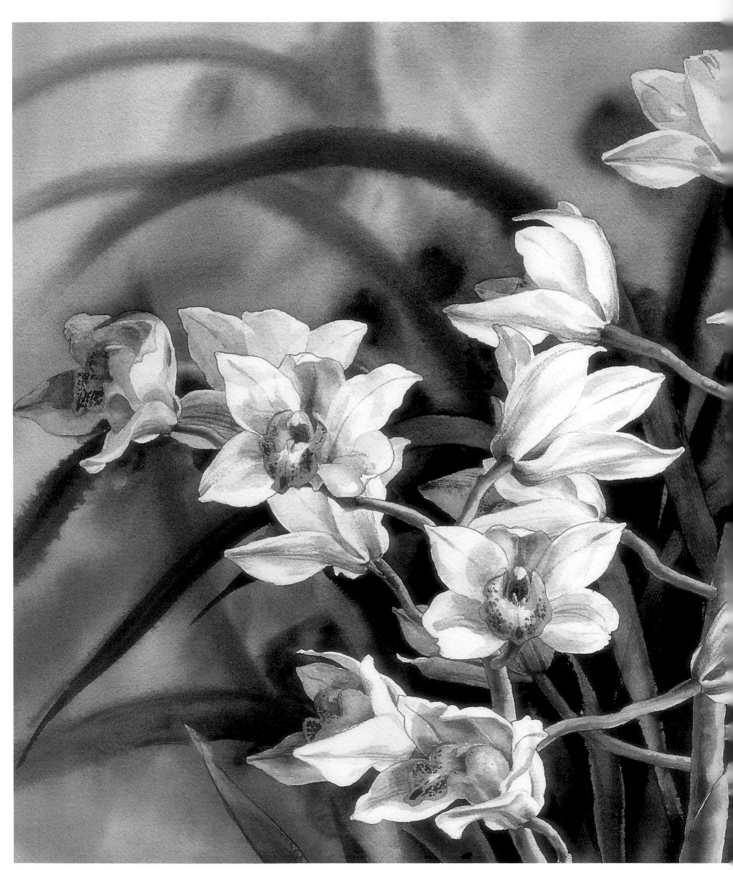

Eymbidium
24″×30″ (61cm×76cm)

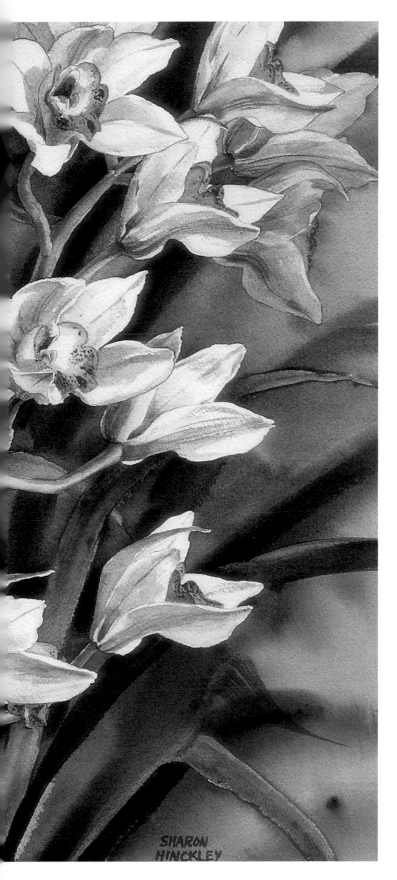

WATERCOLOR BASICS: PAINTING FLOWERS

SHARON HINCKLEY

NORTH LIGHT BOOKS
CINCINNATI, OHIO
www.artistsnetwork.com

ABOUT THE AUTHOR

Sharon Hinckley is originally from the Washington, D.C., area and is a graduate of Stanford University. She has traveled the world and had numerous one-woman shows. Her work is represented in many private and corporate collections including Bank of America, the San Diego Children's Hospital and the Taipei National Museum of History. Her work has appeared in *Spash 3* and *The Best of Flower Painting*. She was commissioned by the U.S. Post Office to design the program cover for the first-day-issue ceremony of the "Fall Garden Flowers" series of stamps.

Sharon always prefers to work from life. Her plein-air style of painting reflects her love of light and color. Her vivid watercolor paintings reflect the beauty of our world. She currently lives in La Jolla, California, with her husband, Kent, and "fur people."

Watercolor Basics: Painting Flowers. Copyright © 1999 by Sharon Hinckley. Manufactured in China. All rights reserved. No part of this book may be reproduced in any form or by any electronic or mechanical means including information storage and retrieval systems without permission in writing from the publisher, except by a reviewer, who may quote brief passages in a review. Published by North Light Books, an imprint of F+W Publications, Inc., 4700 East Galbraith Road, Cincinnati, Ohio 45236. (800) 289-0963. First edition.

Other fine North Light Books are available from your local bookstore, art supply store or direct from the publisher.

10 09 08 10 9 8

Library of Congress Cataloging-in-Publication Data

Hinckley, Sharon.
 Watercolor basics : painting flowers / Sharon Hinckley.
 p. cm.
 Includes index.
 ISBN-13: 978-0-89134-894-8 (pbk. : alk. paper)
 ISBN-10: 0-89134-894-8 (pbk. : alk. paper)
 1. Flowers in art. 2. Watercolor painting—Technique. I. Title.
ND2300.H56 1999
751.42′2434—dc21 98-46911
 CIP

Editor: Glenn Marcum
Production editors: Michelle Howry and Marilyn Daiker
Production coordinator: Kristen Heller

DEDICATION

I would like to dedicate this book to my father, Thomas L.K. Smull. He gave me my very first set of watercolor paints. To this day I use the palette from that little set! I appreciate all of the hours he spent framing my paintings and arranging exhibitions for me. Without his selfless love and support, I could never have achieved so much. He impressed me with the need for careful and continued study. He further taught me that, while the kind of painting I do is important, what is most important is the kind of person that I am.

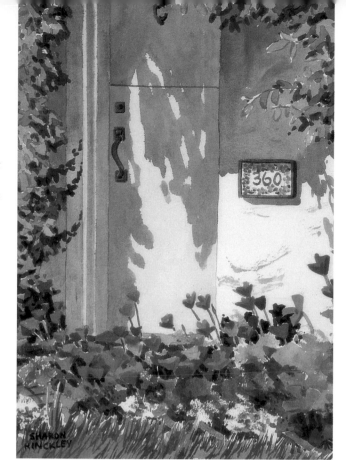

The Yellow Door
14″ × 10″ (36cm × 25cm)

ACKNOWLEDGMENTS

There are so many special people to be acknowledged: caring friends, generous relatives, early teachers, eager students, supportive collectors, curious observers, all fellow travelers on this path of personal growth, painting and exploration.

I'll begin with my grandfather, Robert H. H. Spidel, for giving me my first book on art; my mother, Roberta Smull, and my grandmother, Belva Spidel, for their love of flowers; Jane Burnham, who taught me I didn't have to be perfect to be a painter; and Millicent Bishop for the years she opened her home and heart to my family, myself and my love of art.

I truly appreciate my editor, Glenn Marcum, for his patience, persistence and the jokes he sent along the way! Then there's my enterprising neighbor, Dennis Burns, who lent not only his time and expertise, but his camera and tripod as well! Also my photographer, Michael Campos, was generous in sharing his knowledge and filters, and he made all of the 4″ × 5″ (10cm × 13cm) transparencies used in this book.

Special thanks goes to our son, Bill, for his photographic and computer skills, and for growing up just in time for me to convert his bedroom into a photography studio! And to my stepmother, Ruth Smull, without whose continued support I could not have finished this manuscript in a timely fashion.

Last, but not least, I want to acknowledge my husband, Kent, who taught me how to use the computer and kept nagging me to work at it. He also purchased several of the bouquets and planted many of the flowers appearing in this book, giving his time and energy to nurture both the garden and the author. All the love and support are gratefully appreciated.

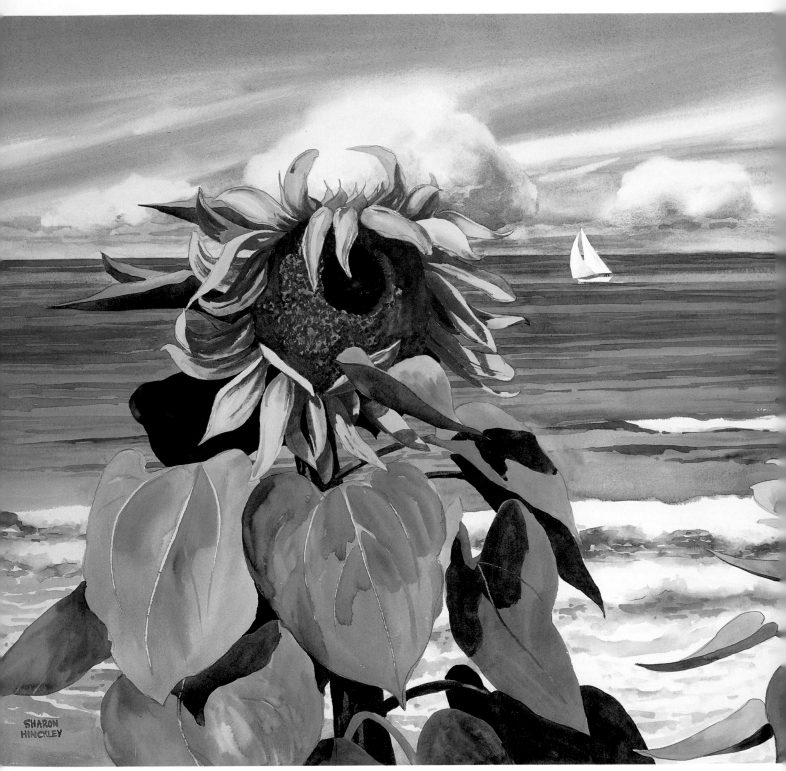

Sunflowers and Beach
25″ × 40″ (64cm × 102cm)

CONTENTS

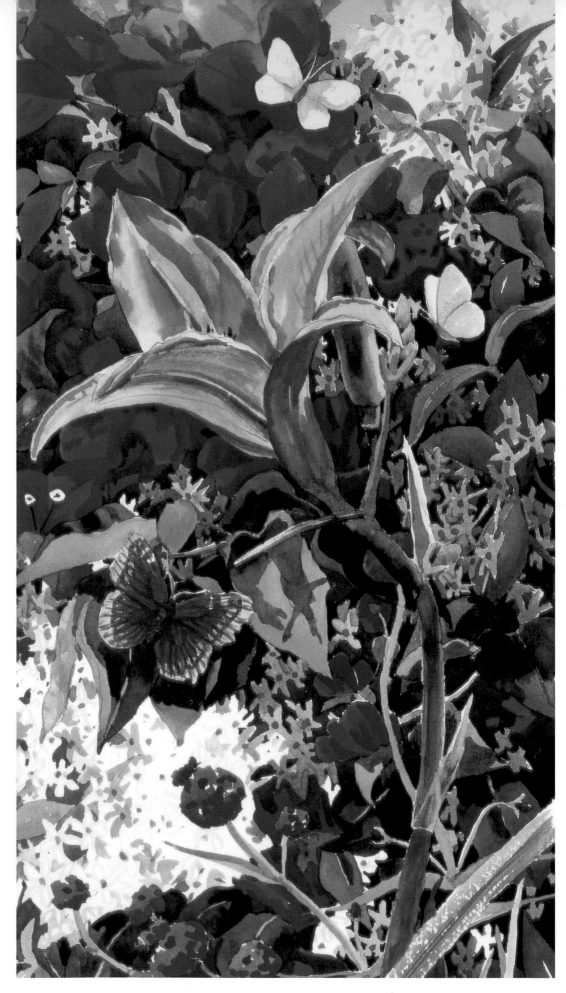

Daylily's Delight
25″ × 9¼″
(64cm × 23cm)

8

INTRODUCTION

Of all the wonderful things in this beautiful world we could paint, why begin with flowers?

Throughout the ages, flowers have been cherished for both their symbolic and intrinsic value. Every civilization attaches meaning to different types of flowers. For the Buddhist, the lotus symbolizes transformation and spiritual growth. The lotus grows through the densest muck and yet it produces a beautiful blossom. In Western tradition, the red rose symbolizes feelings of passion and love.

The oils and essence of flowers are used, internally and externally, for their healing properties. In aromatherapy, their scents are used to attract positive energy and ward off negativity. Flowers also provide the alluring base of perfume!

There are many reasons to paint flowers. First, they are living objects that move, live and grow as we do. Painting a flower gives us a wonderful opportunity to connect with the very heart of nature. Each flower is formed with great precision according to its innate blueprint, yet each bloom is totally unique—even when several blossoms sprout from the same branch!

Painting a flower is a great exercise in focus. Outdoors, the light is constantly changing and flowers move in the breeze. You must learn to pay careful attention to each shape and color to portray the expression of the flower.

Even cut flowers in a vase will move and change over the course of a few hours. Learning to express the essence of a living flower is a good introduction to faster-moving objects: children, puppies and rainbows!

Flowers put us in touch with our happy feelings. Perhaps it's a beautiful fragrance or vivid color. Maybe it's a sense of gentleness and delicacy or a gift from the nature spirits. Whatever the reason, it's absolutely impossible to paint a flower and remain in a bad mood.

In this book, we'll look at basic floral painting concepts, materials (palettes, paints, brushes) and how to set up. I'll also demonstrate basic exercises in color choice and composition that will help you make better paintings.

Then we'll move on to useful techniques for leaf painting. I have observed that many people paint beautiful flowers but fail to support their subject with appropriate leaf and background patterns. Leaves are fun and easy to do. And when you are confident in your ability to set the stage properly, it's easier for your star attraction (the flowers) to take center stage. It's even possible to set the stage in such a way that the leaves themselves can be cast in the starring role!

Next I'll demonstrate techniques for painting individual flowers, honoring their differences and similarities. From there we move on to various flower arrangements, and finish in my favorite place—painting flowers outdoors—combining all the elements of color, composition and design that have been discussed throughout the book. Sound like a lot of work? Don't panic. It's easy to feel overwhelmed when starting a new project. Just remember—when you break your work down into pieces, it stops being work and turns into play.

Painting flowers is a most enjoyable way to spend a day. It's fun. It's easy. It uplifts the spirit. And you have a beautiful painting when you're finished.

BASIC MATERIALS

I love painting! It's such a direct way to enjoy the experience of life, color and nature. I always tell my students that painting is so much easier than photography. And it's really true! In photography it's frequently necessary to buy another piece of equipment—a new lens, camera body, filters, lights . . . ad nauseam—to obtain the desired results. Not so with painting. Once you've invested in a basic set of quality materials, there is no need to make additional purchases to improve the quality of your work. All you really need is to spend time at your easel.

Basic materials can actually be quite simple. All I really need are three brushes (big, medium, fine); three colors (red, yellow, blue); paper and a drawing board. Now I guess it's time for a reality check. I'm sure I could get along with three pairs of shoes, too (casual, dressy, beach). However, my clothes closet definitely shows the result of my love of shoe shopping! And my art closet shows the result of my love of "color shopping"!

In My Studio
19″ × 19″ (48cm × 48cm)

SHARON HINCKLEY

Colors

After much painting and shopping, I have created a palette containing sixteen colors; enough to give me ease and variety of handling, yet not so many to be confusing. Choice is good, but too much choice is exhausting.

Lemon Yellow
New Gamboge
Cadmium Orange
Scarlet Lake
Alizarin Crimson
Opera
Winsor Violet (Dioxazine)
French Ultramarine
Cobalt Blue
Cerulean Blue
Antwerp Blue
Cobalt Turquoise
Emerald Green
Warm Sepia
Alizarin Brown Madder
Raw Sienna

These colors are all manufactured by Winsor & Newton except for the Opera, made by Holbein.

Permanence

All of the above colors (except Alizarin Crimson and Opera) are rated as permanent. I have painted professionally for over twenty years and have never experienced any fading problems with these colors. My studio has a bright, sunny western exposure over the Pacific Ocean. Several years ago I painted all of my palette colors on a strip of paper, then cut it in half. I taped one half to the window with the colors facing the ocean. The other half went into a dark drawer. Over a year later, when I compared both halves, the colors still matched.

Building a Color Chart

All paint manufacturers have sample color charts. My local art supply store supplies them free of charge. I like to read about the properties of the different pigments, but reading isn't enough. Whether you create your own palette or borrow mine, here's an easy way to chart your colors that offers a convenient, at-a-glance reference showing how each hue stands on its own and interacts with others. Prominently displayed in your studio or painting area, this chart will be a valuable tool.

I recommend making this test strip with the colors you want to use. Cut your strip into three pieces. Place one in a window with western exposure, another in a dark drawer and the third by your pillow. This will familiarize you with your palette and dispel any doubts about color permanency.

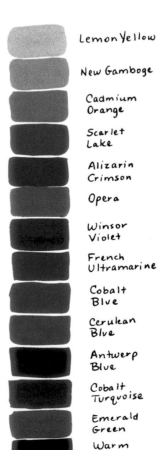

Lemon Yellow
New Gamboge
Cadmium Orange
Scarlet Lake
Alizarin Crimson
Opera
Winsor Violet
French Ultramarine
Cobalt Blue
Cerulean Blue
Antwerp Blue
Cobalt Turquoise
Emerald Green
Warm Sepia
Alizarin Brown Madder
Raw Sienna

Start by painting a square of each color you want to use. I have used all sixteen colors listed in my palette. Write the name of the color next to each square.

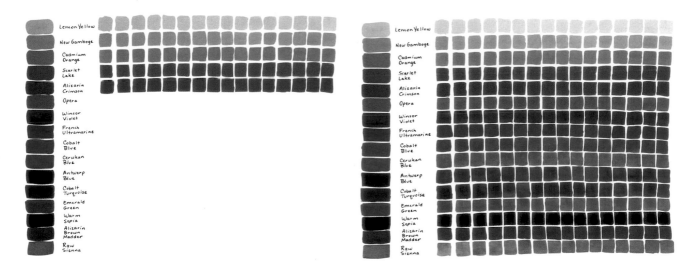

Begin extending each color horizontally to the right of the first color (Lemon Yellow in my example).

Repeat this process until all the colors have been painted out.

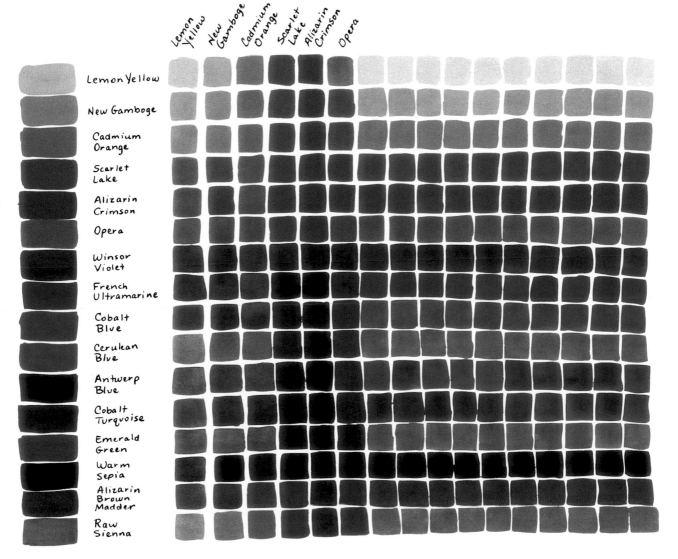

Next, extend the colors vertically one at a time, beginning again with Lemon Yellow, until a second wash is applied to all the original squares. Label each color as you paint.

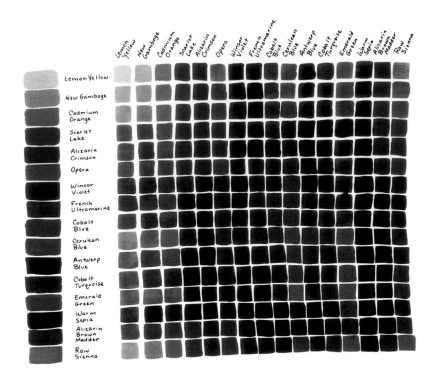

Now you have an accurate record of how each color appears when glazed with each of the others, and how the colors appear at full intensity. You can also see which colors flow easily or cover more completely—Lemon Yellow and Emerald Green are opaque, while New Gamboge and Antwerp Blue are transparent. Together, they produce a beautiful leaf green.

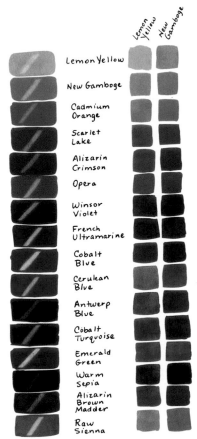

Lemon Yellow
New Gamboge
Cadmium Orange
Scarlet Lake
Alizarin Crimson
Opera
Winsor Violet
French Ultramarine
Cobalt Blue
Cerulean Blue
Antwerp Blue
Cobalt Turquoise
Emerald Green
Warm Sepia
Alizarin Brown Madder
Raw Sienna

Now, go back to each original color square and lift out a strip of color with a wet brush. This way you can see how each color lifts. If you're planning to lift a blue hue all the way back to white paper, you'd better not choose Antwerp Blue!

Combine Those Colors

As you experiment with color, you'll find you like some combinations better than others. I love to use Opera and Lemon Yellow to warm things up. French Ultramarine and Alizarin Brown Madder make wonderful purplish grays while New Gamboge mixed with Cobalt Turquoise makes a beautiful leaf green.

Opera and Lemon Yellow

French Ultramarine and Alizarin Brown Madder

New Gamboge and Cobalt Turquoise

Brushes

All any painter really needs are three brushes: big, medium and fine. On the other hand, a little variety is always nice. I carry thirteen brushes (my lucky number) with me. Some are brand new while others are trusty "old soldiers" (what the Japanese refer to as "broken" brushes) and are excellent for scrubbing color in (or out) and mopping up excess paint and water. Even brushes that have lost their bounce can be useful for creating textures and painting background areas.

You don't have to spend a lot of money on brushes, but do take the time to select good ones. The synthetic/sable blends and some white sables are good. Choose a brush with a lot of bounce, making sure it either makes a sharp chisel edge or comes to a fine point. Any good art supply store will provide water so you can test a brush before buying.

While you can order excellent brushes from catalogs, I always purchase mine from local art supply stores. If you're a hands-on type (like me), it's good to check the points of your round brushes before purchase. Do this by observing how well the bristles form a point when dipped in water. Any good art supply store will provide water for this purpose. And it's always good business to support your local merchants.

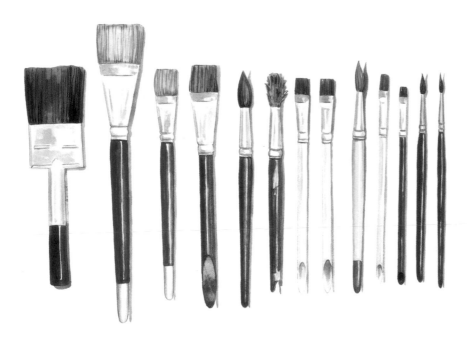

MY FAVORITE BRUSHES (from left to right)
Big brushes: 2-inch (5cm) flat wash brush; 1½-inch (3.8cm) tole painting brush (flat); 1-inch (2.5cm) tole painting brush (flat); 1-inch (2.5cm) aquarelle brush (with a chiseled handle for scraping); no. 12 round (one "new" and one "used")

Medium brushes: ½-inch (1.3cm) aquarelle brush (chisel—one "new" and one "used"); no. 10 round

Fine Brushes: ¼-inch (64mm) aquarelle brush (chisel—one "new" and one "used"); no. 6 round, sable/synthetic blend; no. 5 round, sable/synthetic blend

Stretching Your Paper

Stretching your paper prevents it from wrinkling and buckling while you paint. First, soak your paper thoroughly (I soak mine in the bathtub for fifteen to twenty minutes). Next, remove the paper from the water and allow the excess water to drip off before placing the paper on your painting surface (I use prepared plywood sheets). Beginning in the center of one of the longer sides, staple the paper to your painting surface. Staples should be placed about one inch apart. Let it dry (usually overnight), and you're ready to go.

Setting Up

Indoor Setup

I sit on a swivel chair in front of my studio easel, which is positioned between two tables and a bookshelf. The larger table has a light mounted on it, and holds my drawings and information. The smaller table holds my paints, water, brushes and scraps of white paper (for testing colors). This testing board enables me to know the exact consistency of the pigment on my brush. Is it wet enough? Do I need more pigment or more water? Is it dry enough for a dry-brush stroke?

The bookshelf holds my sketchbooks for easy reference, tissues and rags for lifting and blotting, and a hair dryer. There are also special stones and lucky fetishes collected on my trips and a ceramic spoon my son made in grammar school. Talent and inspiration are wonderful assets, but it never hurts to have a good luck charm or two!

Outdoor Setup

I usually work sitting on the ground, so a beach chair stands in for my swivel chair and a light French easel is the alternative to my bulky studio easel. The earth is my table, and the sun acts as my lamp and hair dryer! Otherwise the outdoor setup is pretty much the same—brushes, palette, water, testing paper, paint rags and tissues. A bag holds drawing aids, pens, pencils and sketchbook.

Many artists like to work standing up, but I'm so tall I have a hard time finding an easel that enables me to stand straight while painting. Sitting on the ground allows me to keep my back straight, and I don't have to worry about where to put all my stuff.

Never leave any debris at a painting site; I always carry a trash bag. When packing up, I always count my brushes to be sure I take home the same number I took out. Once home, I also refill my palette immediately. That way I'm ready to go on the next outing at a moment's notice.

Sometimes my car becomes a traveling work surface. I drive a boxy Volvo, so this works well. First I put down a plastic tablecloth to protect the hood or trunk from scratches. Then I set out my supplies. This is one way I enjoy the pleasure of standing up while painting.

A bookcase keeps sketchbooks, references and supplies close at hand.

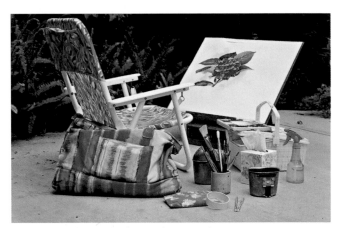

The watercolor artist's outdoor studio.

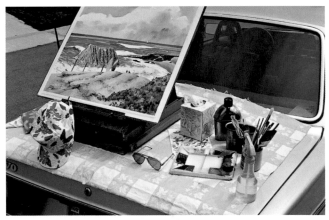

A handy trunk-top painting surface.

Easy Tips for Better Paintings

Choice You may choose to limit your palette, your subject, your paints or even your painting time. The key is *choice*. Although I may have all the colors on my palette, I wouldn't be thrilled with my final painting if I used every one of them!

Color One easy way to make a better painting is to pick a dominant color and explore it. For instance, white flowers on a white background are an exciting possibility. Where are the warms? Where are the cools? How much color can you add and still retain the feeling of whiteness?

Composition There are several popular guidelines for good composition. The four-quadrant grid is my personal favorite. Simply draw two lines, either mentally or with a light pencil, bisecting your paper vertically and horizontally into four equal areas. The rule is to place a different shape in each quadrant.

Control Keep control of the things you can: the quality of your materials, the time devoted to your work and the care of yourself. Always restock your materials at the end of a painting session so you'll be ready for the next day's work.

Contrast The eye automatically finds the area of highest contrast in a painting, so keep that area interesting. Always put your lightest light, your darkest dark and your center of interest in one

White on White
19"×25" (48cm×64cm)

place. You should always be thinking about placing a light shape against a dark shape or vice versa.

Planning Think about your entire painting even while focusing on a specific area. Know the direction you're headed. At the same time, allow the picture to develop and evolve as it will. Don't insist that the painting rigidly conform to a prearranged model.

Unity and Variety Include a variety of shapes, colors, sizes and textures in your paintings. Balance this variety with a sense of unity and harmonious design to excite, not shock, the viewer.

The four-quadrant grid.

A study in contrast.

The Happy Accident It's not a mistake to make a mistake. I think you should use happy accidents for all they're worth! Did you put a spot of red where you wanted blue? Don't be in a big hurry to correct it. It just might help you out of a jam, as it once did for me. While painting *Study in Pink and Green*, I was having difficulty resolving the background. The painting was in the trunk of my car when I drove through a car wash. The trunk had not latched properly (a mechanic's fault, not mine) and I was stunned when I saw runs on my nearly completed painting, until I realized they could solve my background problem—an excellent example of a "happy" accident.

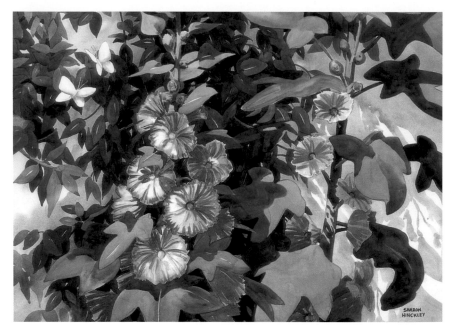

Study in Pink and Green 21"×29" (53cm×74cm)

Light Source Always be aware of your light source. Where is it coming from (direction)? How bright is it (intensity)? What is its quality (mood)? Indoors, it's easy to set up a spotlight to give your subject strong, consistent illumination. Outdoors, there's about a two-hour window of time in both midmorning and midafternoon during which you can work with consistent light. An important reminder: There is only one sun. Make sure your paintings have only one light source. That may sound silly, but many paintings are ruined by conflicting shadows.

Load and Organize Your Palette Load your palette fully, making sure the paint wells are filled with moist pigment every time you begin to paint. You can't paint a vibrant picture with dried-up old paint. A squirt of water and a dab of fresh paint on top, and you're ready to go!

Organize your palette so it makes sense to you. Following the color wheel is best. Once you have a setup you like, don't change it. You'll never have to search for a color in mid-stroke.

Mixing Color My color theory is incredibly simple. Beginning painters should work with only three colors at any one time. For more advanced students, my color theory is, "Smoosh everything together until it looks right!" This is the purpose of making color charts. When an artist is truly in the rhythm and flow of painting, there's no time to think, "What color is it?"

Matching-Brush Technique I use two brushes of similar size and shape, one brush fully charged with color and the other (usually a "broken" brush) containing clear water. This way I can paint a hard edge in one area and quickly fade it out in another. This is also an excellent way to paint shadows and backgrounds.

Multiple-Brush Technique I prefer mixing color on my paper rather than on my palette. This is accomplished by using several brushes, each loaded with a different color. The trick is to remember which color is on which brush!

Shapes There are four basic shapes: circles, squares, triangles and free forms. Circles can be ellipses and oblongs. Many flowers and leaves are rounded, or radiate from a central point. Squares and rectangles, excepting some crystals, only occur in man-made structures. Triangles appear in mountains, crystals, leaves, thorns or structures like the pyramids. A free form doesn't conform to any of the above shapes. If you understand how shapes work, you'll see them everywhere, enabling you to paint anything easily!

Overlapping Paintings are more interesting if shapes are overlapped. Lining up all the objects in a row makes them look like stiff wooden soldiers.

Subject Matter Any subject is suitable for a painting—even a weed! I've seen wonderful paintings of thistles. In the beginning, limit yourself to one to three subjects. As you advance in your artwork, you will naturally develop the skill necessary for greater complexity. Also, sit at a proper distance to view your entire subject clearly.

Theme of Three To keep things simple, I often use the number three. I might limit myself to three main colors, such as red/pink/green or blue/yellow/orange. Or I may limit myself to three main shapes—large, medium and small.

Rules About Rules There are no rules! Seriously, rules are meant to be guidelines and suggestions to get you started in the right direction. If, in the course of your work, you come across something that's a total departure from the known and it seems to work, go for it!

Work From Life Many artists go on location, take a few snapshots, go home, and rearrange them to make a painting "more interesting than nature." How can you make something more interesting than nature? I believe in feeling the energy of and the connection with the earth. This can only be achieved by working outside. Give it a try.

Stiff, uninteresting wooden soldiers.

Eye-catchingly overlapped.

These blossoms illustrate the theme of three.

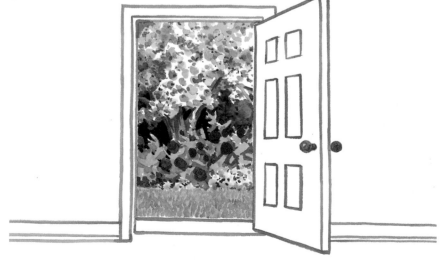

Paint outdoors often. Nature always has something interesting waiting.

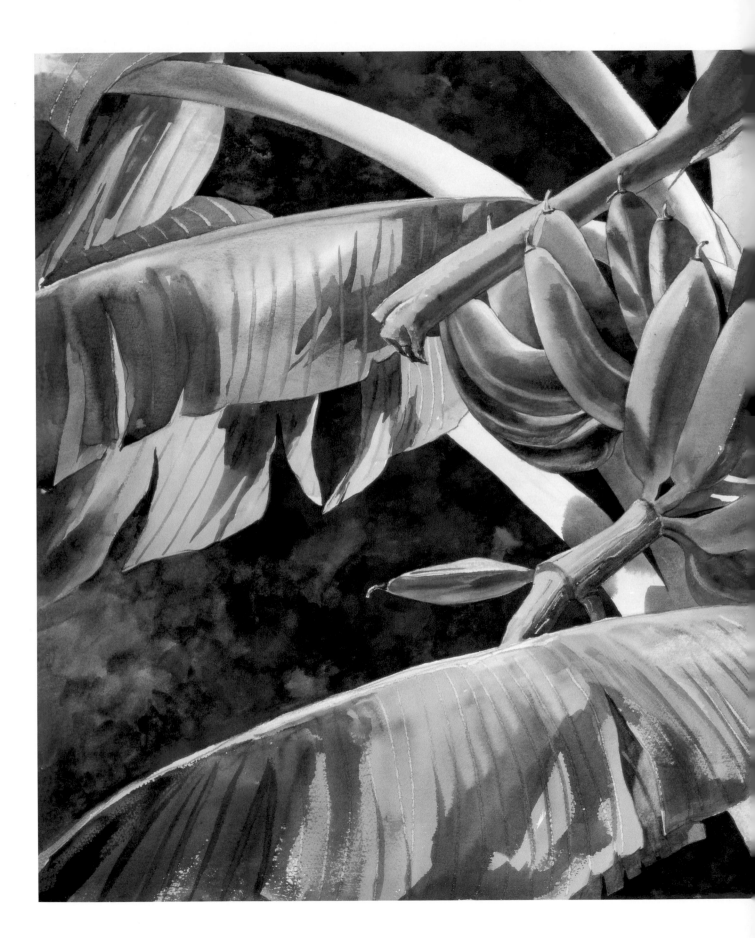

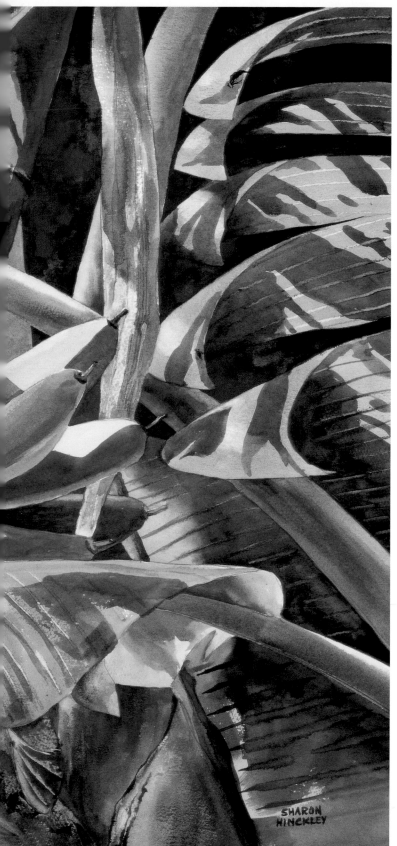

2
LEAVES AND BACKGROUNDS

Many flower paintings get off to a good start and then falter. The artist has paid careful attention to drawing, coloring and shading the individual blossoms, but not enough attention to other details: too many or too few leaves, leaves out of proportion to the flower, flowers that float unconnected to their surroundings.

Often I see paintings where the leaves are a green blob in the background. While sometimes that's exactly what a painting needs, in order for blobs to work they must be the result of conscious choice, not an inability to do better.

This is why it's important to give as much consideration to the background and leaves as to the flowers. After all, you don't want your flowers to be so overpowering that they drown out their supporting background areas or seem to be adrift in an indistinct limbo. Paintings must have a strong center of interest, but no painting is truly complete unless all of its elements work together harmoniously. Each element should complement and, in turn, be complemented by the others.

Go Bananas
21″ × 29″ (53cm × 74cm)

Mixing Greens

Some artists keep green pigment on their palettes. I prefer to mix my greens rather than use tube colors. This way I have a better chance of achieving the variety of nature in my painting. However, I do use Emerald Green. It's such a luscious, albeit opaque, color.

Here are some of my favorite combinations.

Lemon Yellow and Cerulean Blue make a fresh spring green.

New Gamboge and Cerulean Blue make a slightly warmer summer green.

New Gamboge and Cobalt Turquoise combine into almost a jade green.

New Gamboge and Antwerp Blue create a warm, earthy green.

Lemon Yellow and French Ultramarine blend into a rich, cool green.

New Gamboge and Emerald Green also make a fresh spring green—though more opaque than Lemon Yellow and Cerulean Blue.

Opera and Emerald Green make a wonderful blue-gray green, perfect for eucalyptus leaves.

Raw Sienna and Cobalt Turquoise create a green that is almost bronze.

Lemon Yellow and Cobalt Turquoise combine into a delicate moss green.

New Gamboge and French Ultramarine make a blue-black green.

Cadmium Orange and French Ultramarine create a rich green that is nearly brown. It's perfect for duplicating the warm darks hidden between leaves and under crevices.

"Leaf Soup"

Throughout this book I refer to a basic "leaf soup" mix. As mentioned in chapter one, I frequently paint with four or five different brushes in my hand at the same time, each loaded with a different color (sometimes I add one with clear water). This is because I find the color modulations in nature are more easily expressed by allowing pigments to mix on the paper rather than on the palette.

I basically use the same colors to paint all leaves: Lemon Yellow, New Gamboge, Cobalt Turquoise, Cerulean Blue and Cobalt Blue. What varies is the amount of each pigment and the amount of water. When I want a darker hue I add French Ultramarine. To tone down a green I add Alizarin Brown Madder. For spice I add Opera or Emerald Green. Here are examples of my favorite "leaf soup" mixes.

Lemon Yellow, New Gamboge, Emerald Green and Cobalt Turquoise make a bright green mixture.

Lemon Yellow, New Gamboge, Cobalt Turquoise and Cobalt Blue make rich greens.

Lemon Yellow, New Gamboge, Alizarin Brown Madder, French Ultramarine and Cobalt Turquoise create a deep, dark, mysterious green.

Lemon Yellow, New Gamboge, Opera and Cobalt Turquoise create bluish gray greens.

"Palette Soup"

Here is an example of "palette soup" mix. It's made up of whatever is left on the palette after I've been painting for a while. By then, heaven knows what colors it consists of, but it will make a reliable gray that is wonderful for toning down over-bright colors or putting in a background wash. It can also be combined with brighter colors to create an even wider variety in your range of colors.

Now, not only is Nature infinite in her varieties, so are the colors on your palette!

A basic "palette soup" mix.

Here the soup mix flows into a mixture of New Gamboge and Cobalt Turquoise.

Basic Leaf Shapes

The dictionary describes more than fifty different kinds of leaf forms. That's far too many for the brain to absorb and paint, too! We'll keep it simple and narrow it to the four basic shapes: circles, squares, triangles and free forms. While I have yet to see a square leaf, there are an abundance of curved, rounded and triangular shapes in the natural world. For the purpose of this exercise, we'll divide leaves into five basic categories: linear, round, oval, triangular and squiggly. (Five is a little more manageable than fifty!) We'll be using my basic "leaf soup" mix to paint each one.

Linear

The leaves of the agapanthus, gladiolus and daffodil are linear. These are just a few of the many leaves that are linear in shape. The daylily, iris, tulip and oleander are other examples.

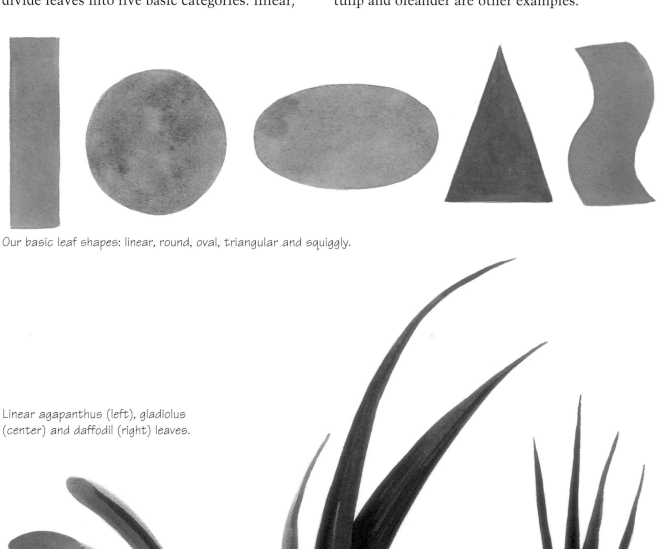

Our basic leaf shapes: linear, round, oval, triangular and squiggly.

Linear agapanthus (left), gladiolus (center) and daffodil (right) leaves.

Round
You'll find round leaves on water lilies, geraniums and nasturtiums.

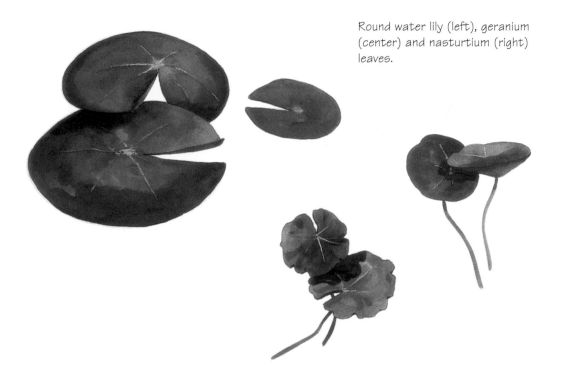

Round water lily (left), geranium (center) and nasturtium (right) leaves.

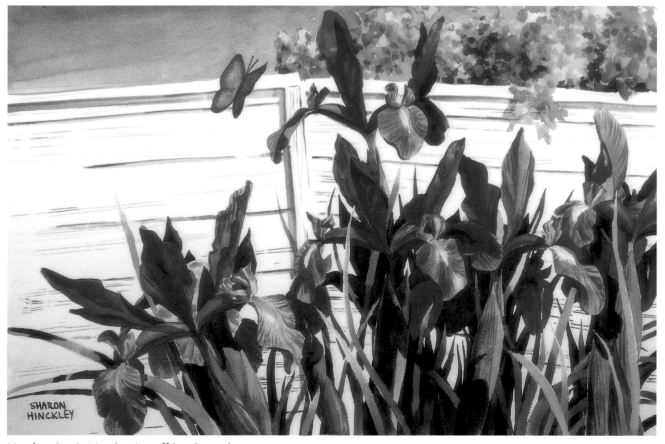

Here's a lovely iris showing off her linear leaves.

Oval

Hydrangeas, orange trees and roses have oval leaves.

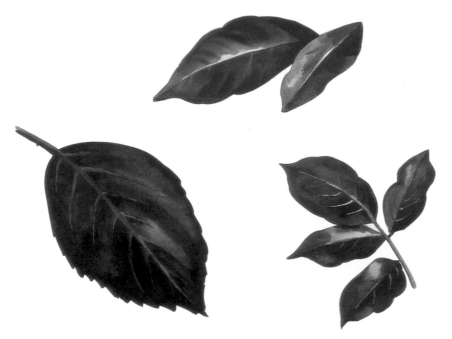

Oval hydrangea (left), orange (center) and rose (right) leaves.

Here's an example of oval leaves at work (with some triangular ferns thrown in for good measure).

Triangular

Ivy, hibiscus and ferns have leaves that are triangular in shape.

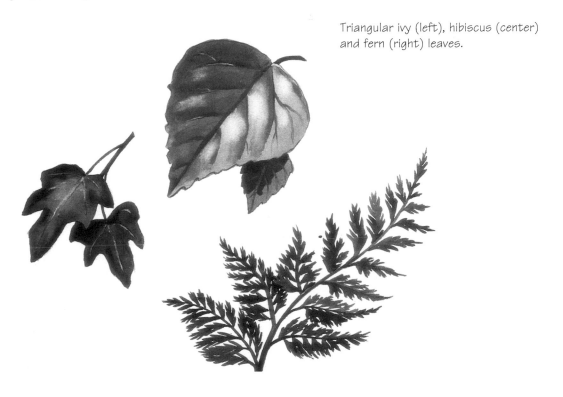

Triangular ivy (left), hibiscus (center) and fern (right) leaves.

Heart-shaped leaves definitely qualify as triangles. Remember, leaves are as important to plants as vital organs are to us!

Squiggly

Squiggly leaves are a bit hard to categorize. They can be challenging to paint, which is why I like to simplify them as much as I can. Squiggly isn't hard to recognize—they have a lot of "stuff" going every which way! Daisies and cosmos are good examples of plants with squiggly leaves. California poppies are another.

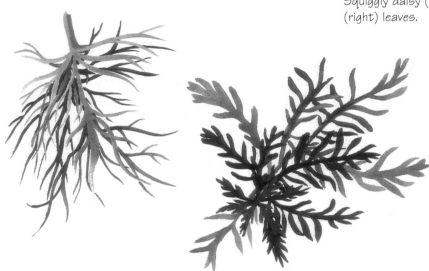

Squiggly daisy (left) and cosmos (right) leaves.

These California poppies have an abundance of squiggly leaves.

All Together Now

Of course, you rarely find a garden or prairie or woodland limited to just one leaf type. Where different flowers tend to congregate, you'll also find a glorious profusion of leaf varieties. Proper portrayal of the greenery, as well as the accompanying blossoms, will make your floral paintings even more beautiful!

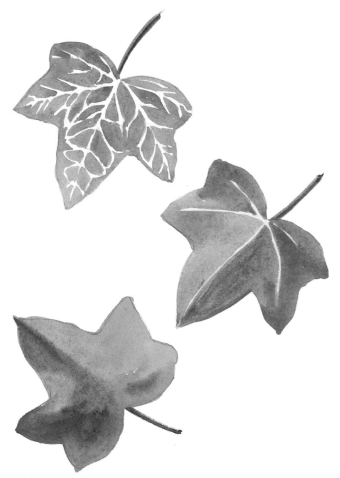

Lilies, Tulips and Iris
19½″ × 30″ (50cm × 76cm)

Just because you can see the veins on a leaf doesn't mean you have to paint them (upper left-hand leaf). It can be a lot more interesting to merely suggest one or two veins (middle leaf) or to leave them out entirely and rely on the use of color to paint an accurately drawn shape (bottom leaf).

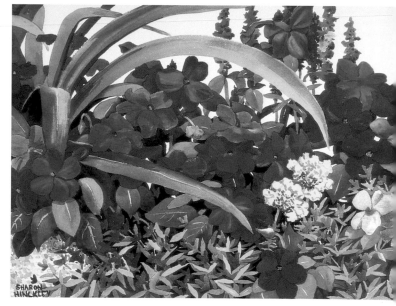

Impatiens
10″ × 14″ (25cm × 36cm)

Backgrounds

Like leaves, backgrounds don't always receive the attention they deserve. While the background is supposed to stay, literally, in the background, it's as important as any other part of the painting and needs careful consideration. In a way, designing a background is a bit like housekeeping—no one notices it when it's done properly. It's only when a background doesn't work that it calls attention to itself.

To properly portray mood and lighting, it's a good idea to spend some time practicing different backgrounds to get a feel for what is possible. Here are some examples.

On a warm day I might like to start with a warm wash of Lemon Yellow, New Gamboge, Opera and a touch of Cadmium Orange. This background is more of a vignette, emphasizing certain areas without filling the entire picture plane.

A cool day calls for a cool wash. The colors used here are Cerulean Blue, Cobalt Blue and Opera. In this example the entire picture plane is covered with diagonal brushstrokes. This was done while the paint was still wet to give a moody effect.

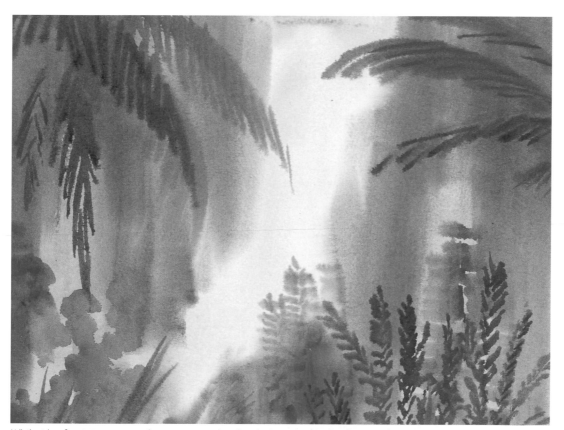

While the first two examples are completely abstract, this background is more realistic. First I applied a wash of "leaf soup" mix containing Lemon Yellow, New Gamboge and Cobalt Turquoise. As the wash began to dry, I added French Ultramarine and Alizarin Brown Madder to the soup for a darker second wash. While the first washes were still damp, this darker color was used to charge in some jungle leaf shapes.

Floral shapes are deliberately suggested in this background. Lemon Yellow, New Gamboge and Emerald Green create a spring-flavored "leaf soup" for the first wash. Cobalt Turquoise and Antwerp Blue are added to the soup for a deeper second wash. Next, areas of Lemon Yellow, New Gamboge and Opera are dropped in, followed by touches of Winsor Violet and Cadmium Orange. Finally, spatters of soup mix are thrown on just for fun.

Notice how a well-integrated background creates a cool, dark, welcoming environment for these white lilies.

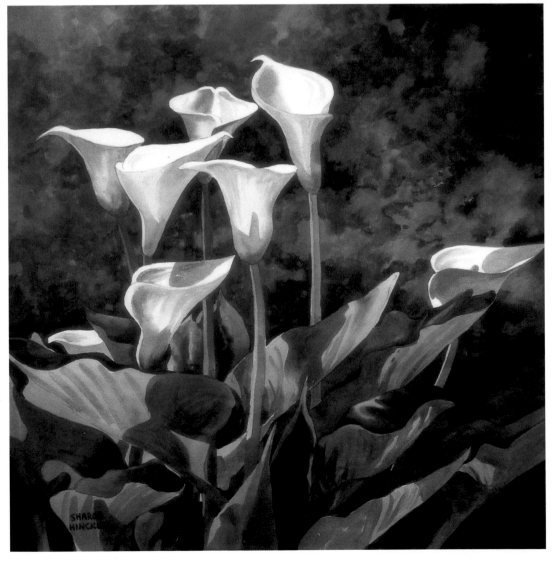

Although this painting has a background, it still looks flat.

A painting with no background is drained of all dimension and depth.

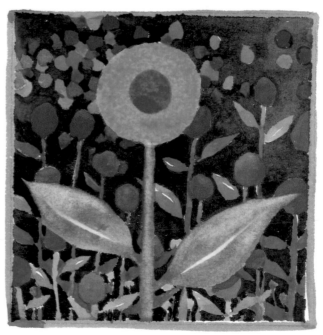

The answer is contrast. A dark, cool background pushes warmer, bright objects forward, creating multiple planes. The reverse is true of a warm background and cool objects.

Tropical Mood

Now that we've looked at some of the pieces of the puzzle (light, color, composition, leaves and background), let's start putting the pieces together. We'll begin by painting some dark leaves against a light background. These are the leaves of a banana plant that grows in my garden. The sun was hidden behind clouds the day I painted this, so I worked with filtered light. There was a lot of moisture in the air, which lent a tropical feel to the atmosphere.

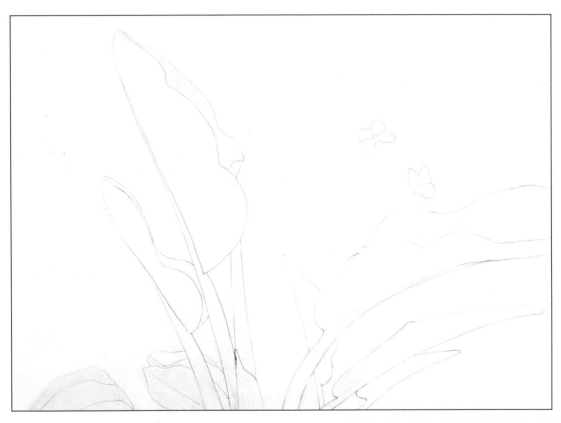

Step 1
Draw the leaves. These are large leaves, so you'll want to use large paper. I'm painting on a full sheet of stretched Arches 140-lb. (300gsm) rough paper.

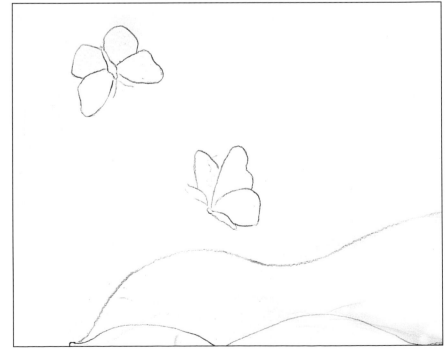

There were a couple of butterflies fluttering about, and I couldn't resist drawing them. They'll add a nice splash of color to the painting.

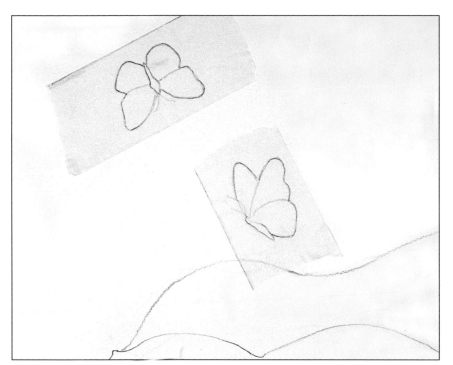

Step 2
Make a stencil out of masking tape to cover the butterflies. This will allow you more freedom when you apply your washes. Of course, you can use liquid frisket, if you prefer. Place tape over the butterflies and trace their shapes with a no. 2 pencil.

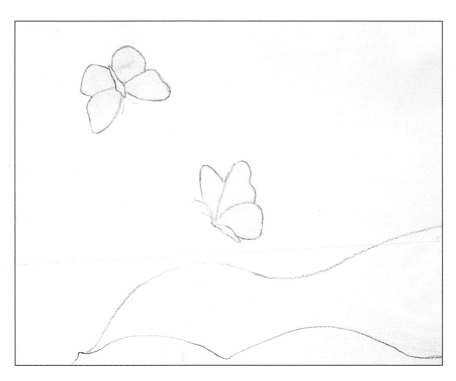

Step 2 (continued)
Remove the tape, cut out the butterfly shapes and place the tape stencil back over the drawings. Be careful to seal the tape edges to the paper. Now you can throw paint in any direction you choose.

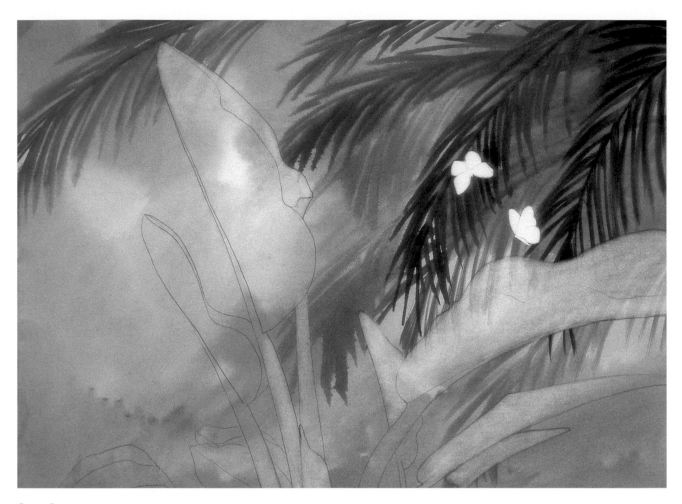

Step 3

We'll try for a "jungle" background on these large leaves. Work wet-into-wet with lots of clear water and large brushstrokes of Lemon Yellow, New Gamboge and Opera. Allow these colors to blend on the paper instead of mixing them on your palette. Continue working wet-into-wet and add more New Gamboge, Emerald Green and Cobalt Turquoise, still mixing on the paper, not the palette.

Use a large brush to stroke in the palm fronds. Continue using New Gamboge, Emerald Green and Cobalt Turquoise. As the paint dries, add Cobalt Blue, Antwerp Blue and French Ultramarine to this "palm frond soup" mix. Sponge out some of the color on the banana leaves. Don't worry if some stain remains—it won't show when you overpaint the leaves later.

Step 4

Remove the masking from your butterflies. The advantage of masking tape is that you can paint over it with complete abandon; the disadvantage is that sometimes it leaks. But don't be discouraged if you find a few little runs at the edges of your butterfly wings. You can clean them up with a little clean water and a ¼-inch (64mm) flat brush. Use a kneaded eraser or art gum eraser to rub out the remaining pencil lines.

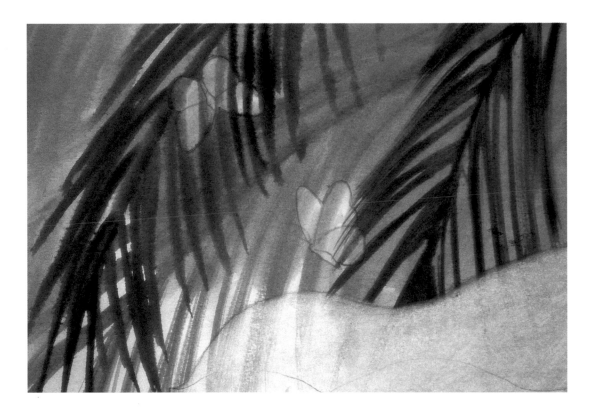

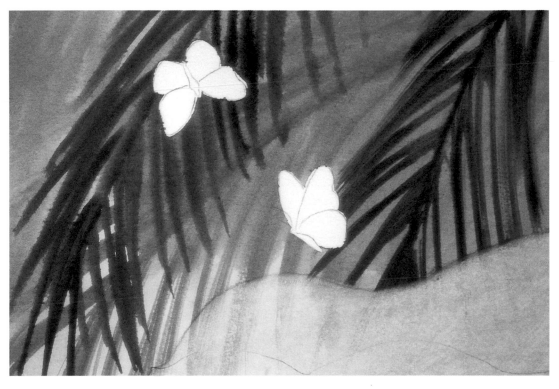

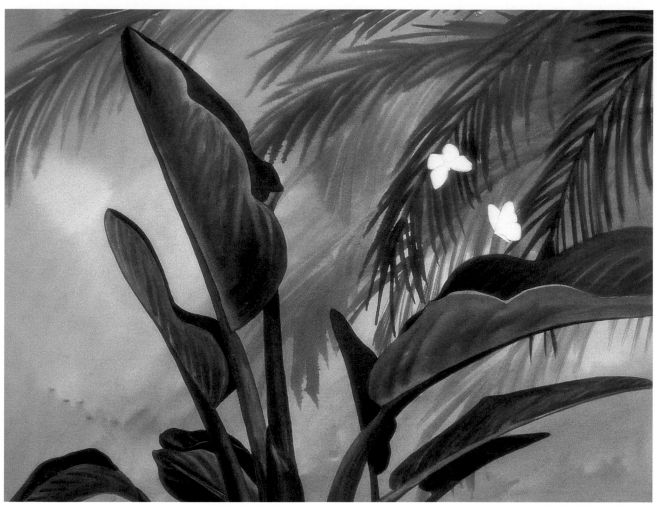

Step 5
Begin washing in the banana leaves using Lemon Yellow, New Gamboge and a few touches of Opera. Use each one of your blues; start with Cobalt Turquoise and add Antwerp Blue, Cerulean Blue, Cobalt Blue and a few touches of French Ultramarine. You can even use some touches of Emerald Green if you like. Let your eye be the guide to your color placement: a little warmer here, a little more blue there. Use wet-into-wet brushstrokes to suggest the vein pattern on the leaves.

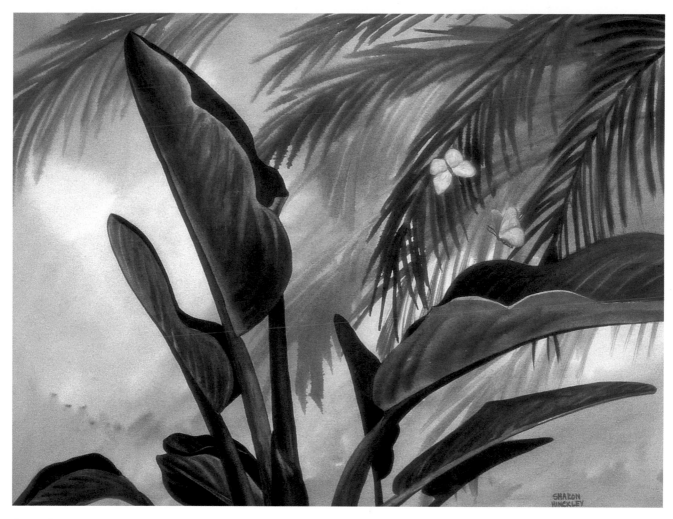

Step 6

It's time to paint the butterflies. Paint the basic butterfly shapes with Lemon Yellow, New Gamboge and Opera. For variety, use a little more Lemon Yellow for the smaller butterfly and a little more New Gamboge and Opera for the larger butterfly. To complete the butterflies, overpaint them with Lemon Yellow, New Gamboge and Opera mixed with a little Raw Sienna. For the bodies and antennae, add some Winsor Violet and French Ultramarine to this mix.

Greenbacks

Now that we've painted dark leaves against a light background, let's reverse the process. The technique of applying dark paint next to or around light paint is called negative painting. What an ironic name for such a positive way to create beautiful paintings! This juxtaposition of dark and light enhances the luminosity of the light areas. Our subject is a loquat tree that appeared in my garden one day.

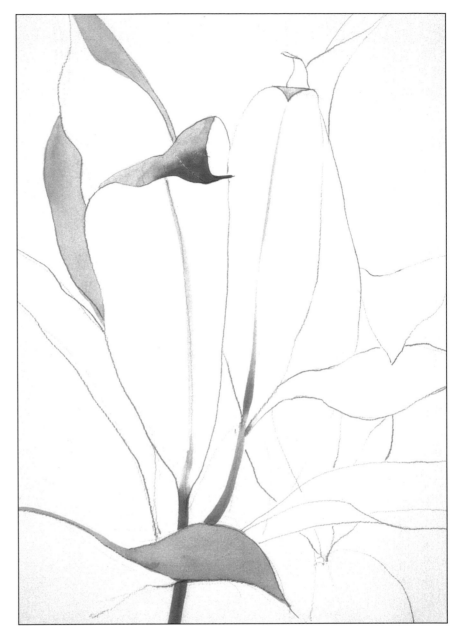

Step 1
Draw your primary leaf shapes. Mix a "leaf soup" of Lemon Yellow, New Gamboge, Cobalt Turquoise, Cerulean Blue and Cobalt Blue, and begin to paint your lightest lights—a few leaf tips and one light-reflecting leaf.

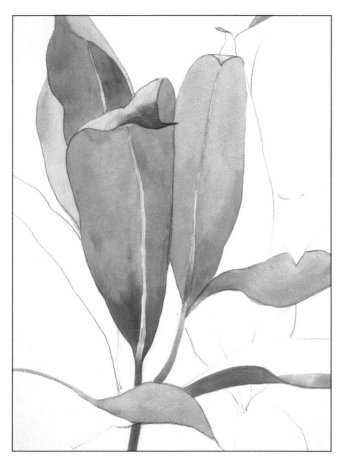

Step 2
Now start painting the basic leaf shapes, still using "leaf soup." Notice that even at this early stage, there is subtle variety in the greens and first light shadings. No two leaves are exactly alike.

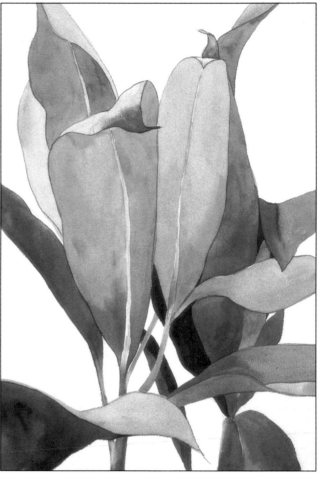

Step 3
Add Alizarin Brown Madder to your mix and begin painting the heavier shadings.

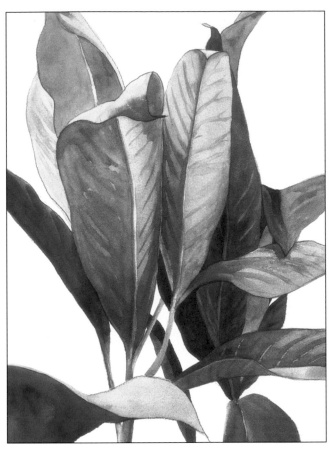

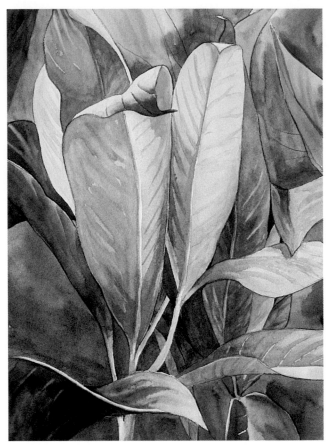

Step 4

Continue shading and detailing. Remember to keep the upper surfaces lighter and cooler and the undersides of the leaves warmer and darker.

Step 5

Now it's time to add a darker chorus of background shapes. For depth and variety, mix some Opera and Alizarin Brown Madder with your blue pigments to introduce purplish and bluish background colors.

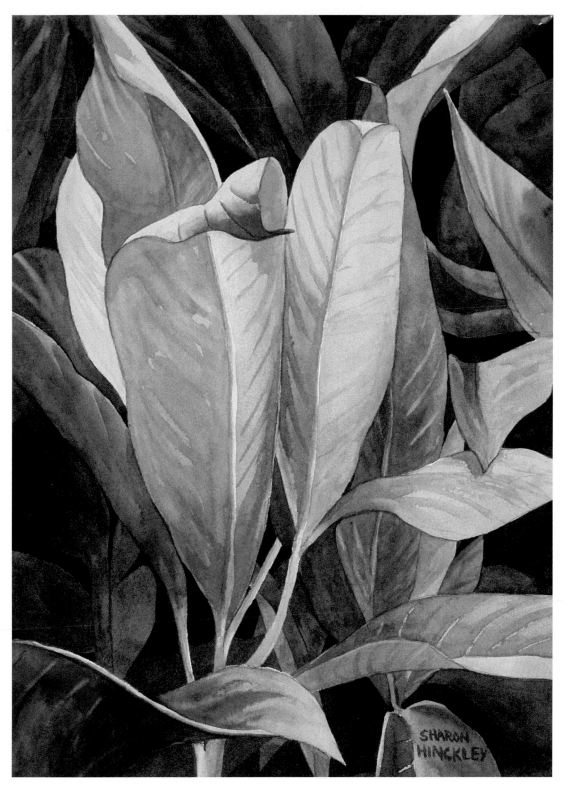

Step 6

Finally, add the finishing background leaves. Be careful to paint them darker in value and duller in intensity to keep them in the background. Also, darken some of the deepest background areas to black. A wonderful black-green can be made by mixing New Gamboge, Alizarin Brown Madder and French Ultramarine.

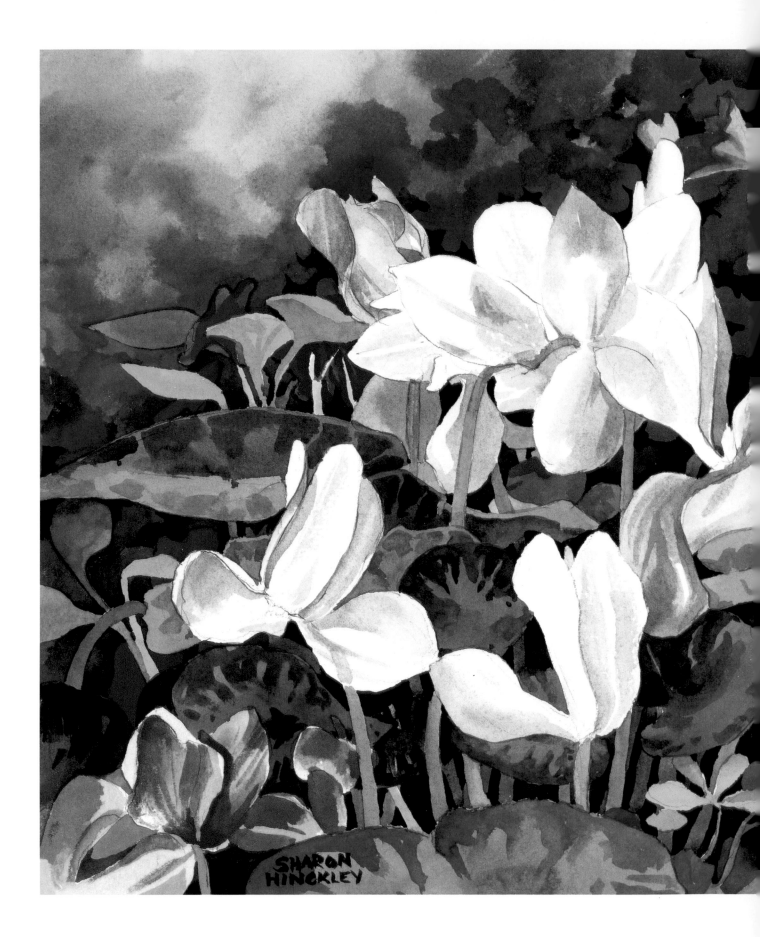

INDIVIDUAL FLOWERS

I like to tackle projects by doing one thing at a time so I don't feel overwhelmed. I like to paint the same way. Painting is like making a quilt. You have all these wonderful pieces of material—so many shapes, bright textures and wonderful colors. Where do they all go? How can you organize all of this information into a coherent pattern?

In this chapter we'll discuss different types of flowers: radiating, puffy, tropical and popular garden favorites. Study flowers for their similarities and differences. Once you truly understand the structure of the flower, you won't have to concentrate so hard while painting. You'll be free to allow your creative energy to express itself in a way that's coherent and colorful.

Cyclamen
10″ × 14″ (25cm × 36cm)

Radiating Flowers: Daisies

Daisies are sun-loving flowers that conjure up images of innocence. They grow in gardens and in the wild. Daisies come in different types, from big showy Shastas to delicate marguerites. They also come in shades of white, blue and yellow. We're going to paint some white marguerites. We'll be working with two main shapes: circles for the flowers and squiggly for the leaves.

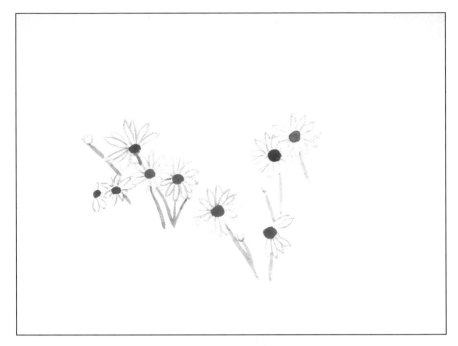

Step 1

Make a light pencil drawing of the blossoms. Paint the daisies' yellow centers with New Gamboge and Opera. Vary these centers—make some round and others more oval; some yellow and others more orange. With a sharply pointed brush, reinforce the petal shapes with a light wash of Cerulean Blue and Alizarin Brown Madder. Paint some of the stems with Emerald Green and New Gamboge.

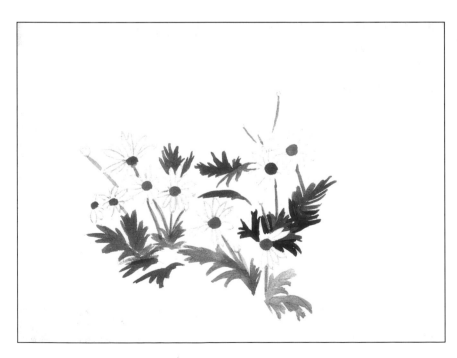

Step 2

Use a "green leaf soup" mix (New Gamboge, Cobalt Turquoise, Emerald Green) to paint the first basic leaf shapes. Daisy leaves are squiggly, so do exactly as you please here. Use Cobalt Blue to darken the leaf shapes.

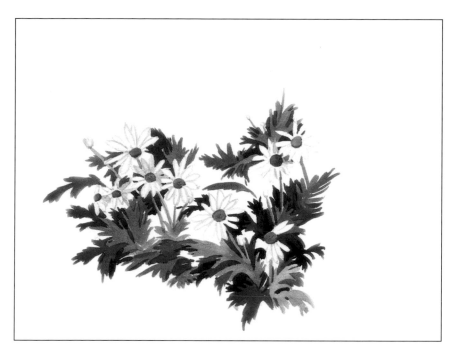

Step 3
Continue painting leaf shapes and stems. Add more shading to the daisies' centers with Alizarin Brown Madder.

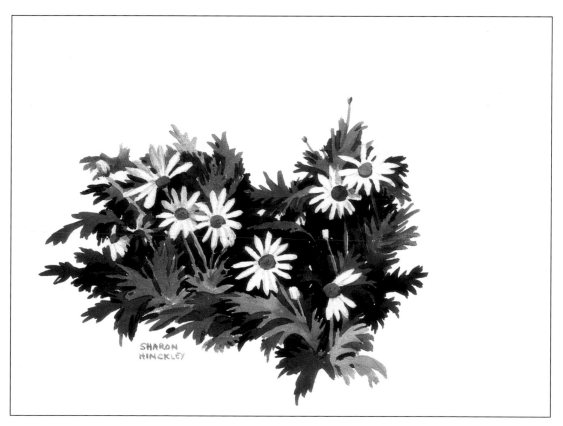

Step 4
Paint a few more leaf shapes. For the darkest shadows and shapes in between the leaves, add French Ultramarine and Alizarin Brown Madder to the "leaf soup" mix. Now you can add a butterfly or a bee; I chose a ladybug!

Radiating Flowers: Black-Eyed Susans

Black-eyed Susans are similar in shape to daisies but have dark, conical centers. During the frontier days, black-eyed Susans grew wild throughout the American Southwest. They grow well in any type of soil and flourish in full sun or partial shade.

Step 1
Carefully draw the shapes of the black-eyed Susans.

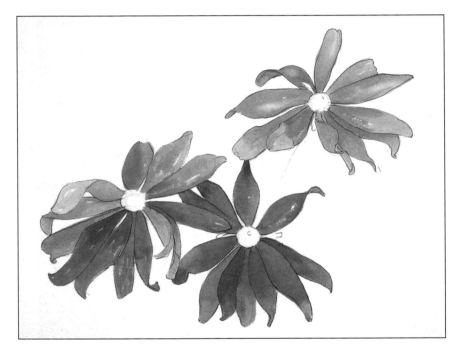

Step 2
With my special "black-eyed Susan" mix (New Gamboge and Lemon Yellow, with a little Opera for warmth and a little Emerald Green for coolness), vary the color of each flower. Put more yellow on the upper right flower, more orange on the left flower and more green on the bottom one. The petals' upper surfaces should be a warm yellow, while the undersides should be more green.

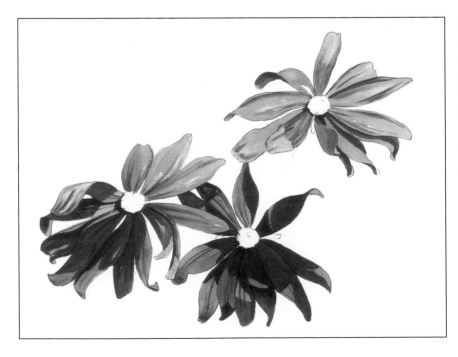

Step 3
Add Alizarin Brown Madder to the "black-eyed Susan" mix for a darker, deeper warm, and add Cerulean Blue and Cobalt Blue for darker cools. Paint cooler, darker shadows on the lowest flower to push it into the background.

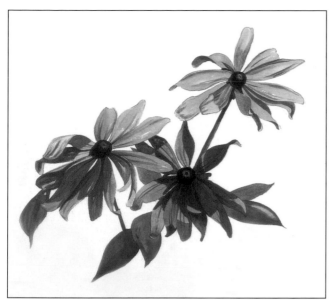

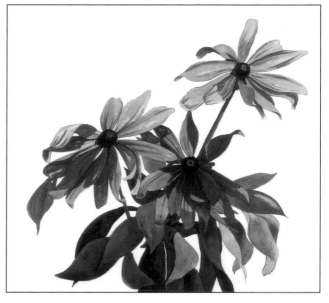

Step 4
Paint the flower centers fairly dark using whatever is on the palette ("palette soup" mix), plus some French Ultramarine and Alizarin Brown Madder. Vary the centers—make one more blue, one more red and one more lavender. Use the "leaf soup" mix to paint a couple of stems and some leaves.

Step 5
Use a "leaf soup" of New Gamboge, Cobalt Turquoise, Lemon Yellow and Cobalt Blue to paint the remaining leaves.

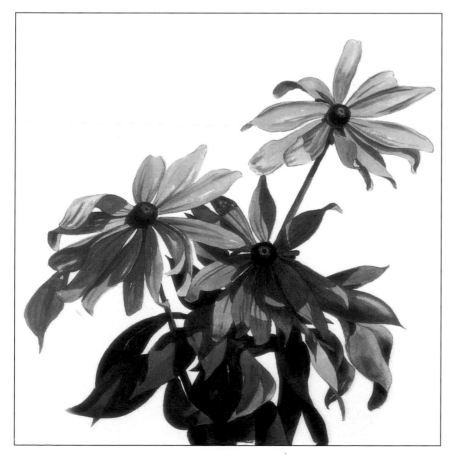

Step 6
Paint the final darks and shadows by adding French Ultramarine and Alizarin Brown Madder to the "leaf soup." Now it's time to stand back and look at your painting for a while. You can always touch up paintings later. . . perhaps we'll come back to this one.

Radiating Flowers: Mantilija Poppies

Like black-eyed Susans, Mantilija poppies were once considered a weed. They are hardy and able to grow in unforgiving soil. Unlike other radiating flowers we'll paint, Mantilija poppies have six large, floppy petals that look and feel like slightly crumpled tissue paper.

Mantilija poppy petals are arranged in two triads, one on top of the other. From the top they look something like this.

Step 1

Draw the outer shape of the flowers, then tone them lightly with a touch of Lemon Yellow and Opera. Paint the yellow centers using New Gamboge and Opera. Warm the upper flower's center by adding Alizarin Brown Madder. Cool the lower flower's center with Emerald Green. No two colors in nature are exactly alike; your paintings should reflect this variety.

Step 2

Repeat all of the colors used in step 1. (In fact, I lifted some shadow color from the underside of the petal on the upper right where I had gone too dark in step 1.)

Step 3

Begin the background with some "sky flavoring," using a wash of Cobalt Blue, Cerulean Blue, Alizarin Brown Madder and Opera. Bring out the white of the poppies by surrounding them with color.

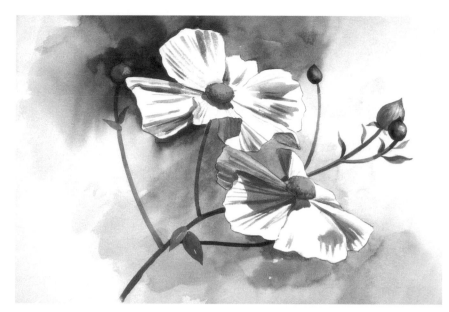

Step 4

Go over most of this "sky flavoring" with a light wash of "leaf soup." Then paint the stems, leaves and buds. With a clean brush and clear water, lift out a bud to the left of the upper flower. Start painting secondary shadows at this point.

Step 5

Using more "leaf soup," keep working on leaf shapes. Be careful to show their varied forms.

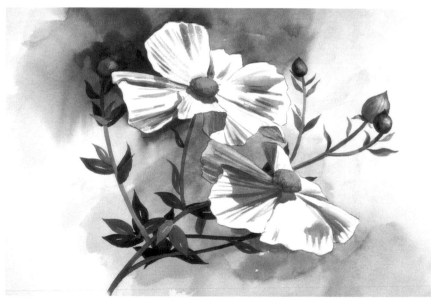

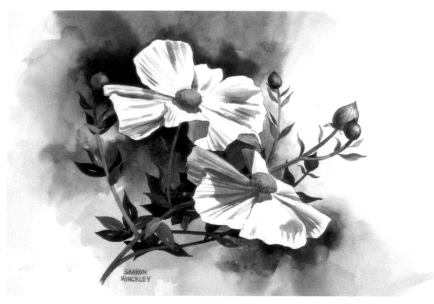

Step 6

Brush in some final darks, primarily with French Ultramarine, Alizarin Brown Madder and New Gamboge. These dark shadings will appear to be leaves. Add more where needed to emphasize the floral pattern. Sign your name with a medium to light green wash.

Radiating Flowers: Cosmos

Another hardy flower, cosmos come in white, pink and lavender. They're not fussy about the quality of their soil and grow easily in sunlight and partial shade.

Step 1

Draw the most important flowers and establish them with a "purple petal" mix of Opera, Cobalt Blue and Cerulean Blue. Paint the flower centers with New Gamboge and Lemon Yellow.

Step 2

Paint the shadows on the petals by adding a touch of Alizarin Brown Madder to your "purple petal" mix for warmth. Use Raw Sienna and Alizarin Brown Madder to shade the flower centers and to bring out their rounded forms. Paint the darker blossoms with a combination of Opera, Cobalt Blue, Cerulean Blue and a touch of Scarlet Lake.

The same colors used in different proportions produce very different results. Adding a touch of another color varies these results even more. These squares were all painted with Opera, Cerulean Blue and Cobalt Blue. However, the left-hand square was painted with more water, while a little Scarlet Lake was added to the right-hand square.

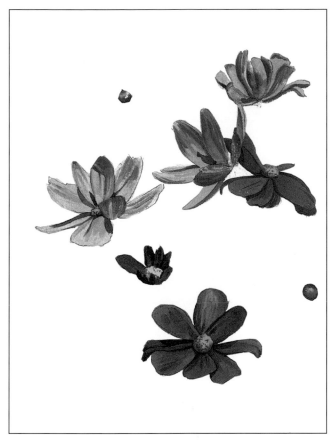

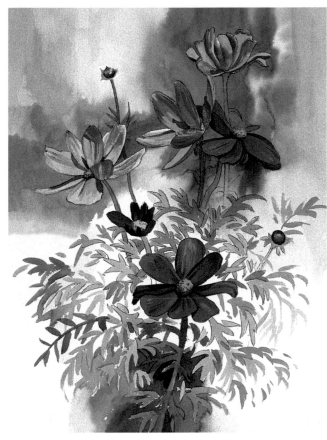

Step 3

To add some buds for variety, use both versions of the "purple petal" mix (step 1 and step 2). Paint shadows on the darker flowers, this time altering the "purple petal" mix with touches of French Ultramarine and Alizarin Brown Madder.

Step 4

Begin painting the major leaf patterns, starting with the lighter foreground patterns and working back to the darker background leaves and shadows. Use "leaf soup" mixes of New Gamboge and Cobalt Turquoise for the lighter patterns and cooler shades of New Gamboge and Cerulean Blue for background leaves and shadows.

Step 5

Continue painting the leaves, working from middle to dark values, adding the darkest dark last. Look for a variety of shapes and values; you can even go back around the dominant flowers with French Ultramarine, New Gamboge and Alizarin Brown Madder.

Puffy Flowers: Hydrangea Blossom

Hydrangeas love water and come in shades of white, pink, blue and lavender. They are huge flowers with big leaves, so this is a good opportunity to work on a large sheet of paper with large brushes. The petals will require some intricate work with smaller fine-point brushes.

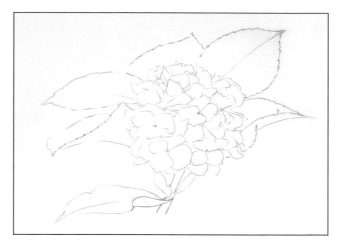

Step 1

Draw the petals and leaves. Hydrangeas have a lot of petals, so don't worry about showing each one. Choose the most dominant petals and show the variety of shapes and angles.

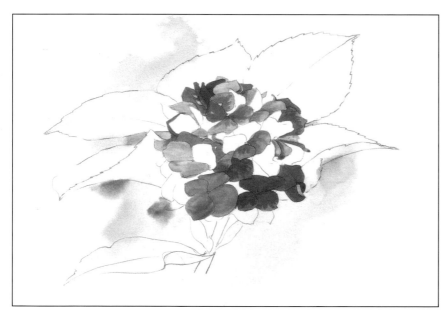

Step 2

Paint in background washes of Lemon Yellow, Opera and Emerald Green. When these washes are dry, use Lemon Yellow, Opera and Cerulean Blue to paint some petal shapes, grouping lights and highlights together. Tip: Squinting frequently will help you see the light shapes more clearly.

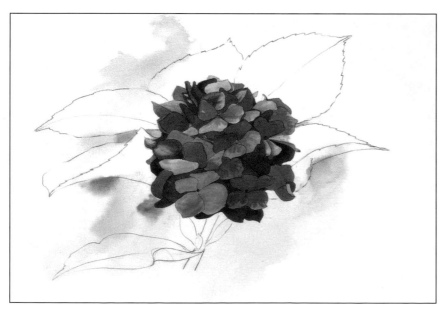

Step 3

Paint the flower centers with Lemon Yellow, Emerald Green and Cerulean Blue. Work on more petal shapes using Opera, Cobalt Blue, Cerulean Blue and a touch of Lemon Yellow. At this stage, focus mainly on the color changes.

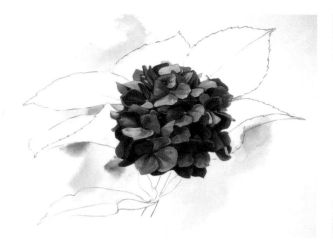 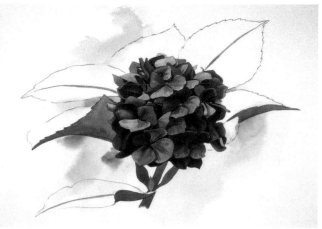

Step 4
Now we need dramatic value changes to unify the rounded blossom form and to bring out the subtle shapes. Use Lemon Yellow, Opera, Cerulean Blue, Cobalt Blue, French Ultramarine and Alizarin Brown Madder.

Step 5
Paint the stems, baby leaves, midlines and leaf undersides with a mixture of Lemon Yellow, New Gamboge, Raw Sienna, Cobalt Turquoise and Opera.

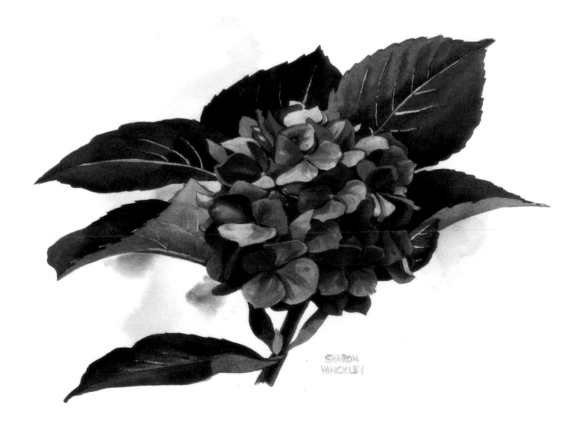

Step 6
To finish, tone down the yellow-green centers as needed and paint the final leaf shapes with Lemon Yellow, New Gamboge, Cobalt Turquoise, Cobalt Blue and French Ultramarine. Add touches of Opera and Alizarin Brown Madder for warmth.

Puffy Flowers: Geraniums

The common geranium is a member of the Pelargonium family. We'll be painting a hot pink Pelargonium and a soft pink ivy geranium. As you can see, even though the two flowers are related, they are very different. The hot pink flowers have fat, round petals while the light pink ones have thin, narrow petals.

Step 1
Begin painting the ivy geranium petals with washes of Opera, Lemon Yellow and New Gamboge. Add Cerulean Blue to the shadowy areas, and use Alizarin Crimson for the bright touches of red at the flower's center. Paint the stem with a "leaf soup" of New Gamboge, Cobalt Turquoise and a touch of Opera.

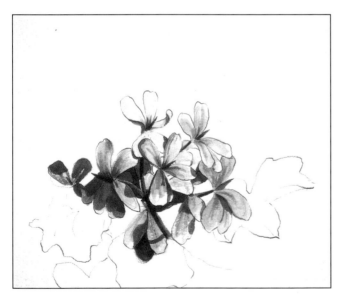

Step 2
Using these same colors, add more petals and shadows.

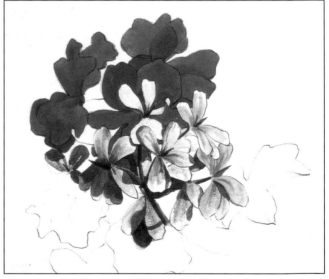

Step 3
Now work on the background geranium using Opera with tiny hints of Lemon Yellow, New Gamboge and Cerulean Blue. If it seems too bright at this stage, it can easily be toned down later. Leave light spaces to indicate lighter petals poking through the darker petals.

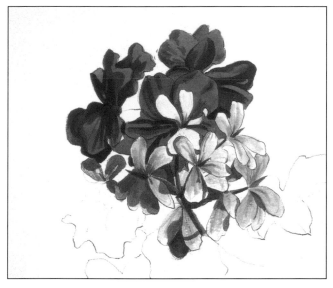

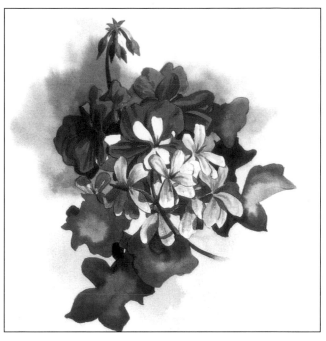

Step 4

Tone down the Pelargonium with Opera, Cobalt Blue, Alizarin Crimson and Cerulean Blue. Use these colors to indicate shadows cast across these petals. Use Cerulean Blue, Cobalt Blue and Alizarin Brown Madder for shadows on the lighter petals.

Step 5

Brush on a "leaf soup" wash behind the flowers to bring them forward. Begin painting the basic leaf shapes using Lemon Yellow, New Gamboge, Cerulean Blue and Cobalt Blue.

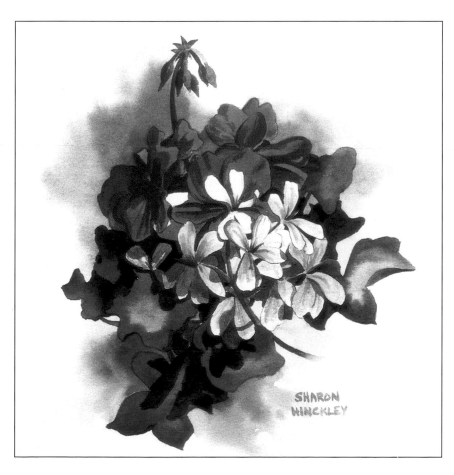

Step 6

In this final stage, add some new little buds at the top. Paint shadow patterns on some leaves by adding French Ultramarine and Alizarin Brown Madder to your soup mix. Add more background color using Cobalt Turquoise. Finally paint some sharp darks using a mix of French Ultramarine, Alizarin Brown Madder and New Gamboge.

Puffy Flowers: Mexican Paper Flowers

Normally I don't enjoy painting artificial flowers, but these Mexican paper flowers are different. They are made by hand and each one is unique. We'll return to the real thing with the next project, but I would like this painting to be a reminder that, while this is a floral painting book, the principles I describe can be applied to any subject, from paper to platypi.

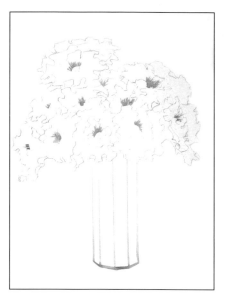

Step 1
Draw the basic flower shapes and octagonal vase. Paint lines to define the vase's shape with Cerulean Blue, Opera, Alizarin Brown Madder and Emerald Green. Vary the weight and color of your lines. Splash in the flower centers with Lemon Yellow and New Gamboge.

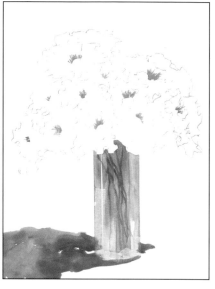

Step 2
Wash the sides of the vase with Lemon Yellow, Opera, Cerulean Blue, Emerald Green, Raw Sienna, Alizarin Brown Madder and Cobalt Blue. Paint each plane a slightly different hue. Wash the shadow using Cerulean Blue, Cobalt Blue, French Ultramarine, Alizarin Brown Madder and a touch of Opera. Paint the shadow warmer (redder) at the vase's base and cooler (bluer) as you move upward.

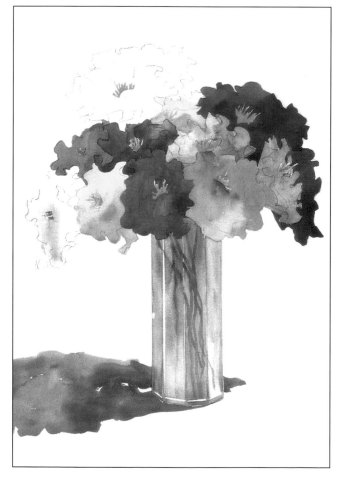

Step 3
Paint the basic flower colors. I used practically every color on my palette. Feel free to experiment!

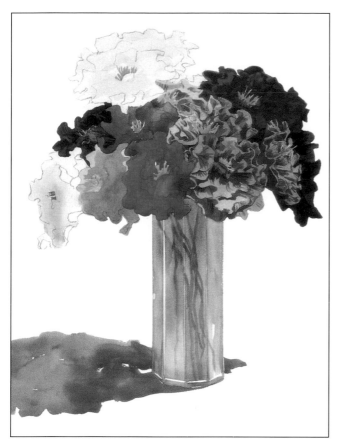

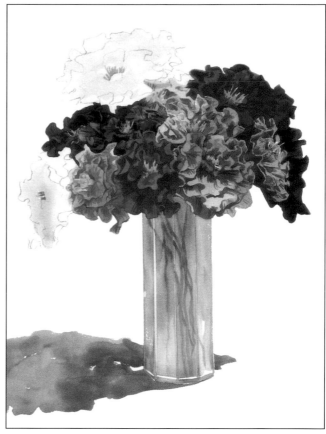

Step 4

Continue to work on the orange and yellow flowers. Add a touch of Cobalt Turquoise and add shadows to the light turquoise flower. Emphasize the curly patterns in the paper and the individual colors of each flower.

Step 5

Define the shadow pattern on the orange flower with a mixture of Alizarin Brown Madder and Scarlet Lake. Use a mixture of Opera and Cerulean Blue on the pink flower. To define shadows on the other flowers, use a darker version of each flower's color, or choose a hue from the same color family.

Step 6

Paint shadows on the white flower. Use Cobalt Blue, Cerulean Blue and Alizarin Brown Madder for a basic "white shadow" mix. Enhance this with touches of Opera, Raw Sienna and New Gamboge, especially on the flower's lower left petals. This flower provides a wonderful opportunity to play with reflected light.

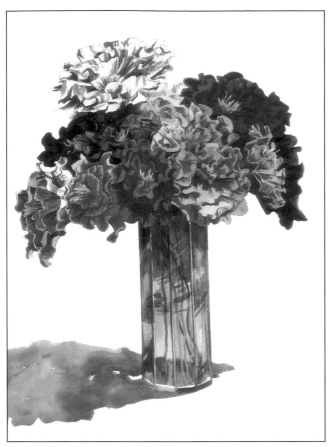

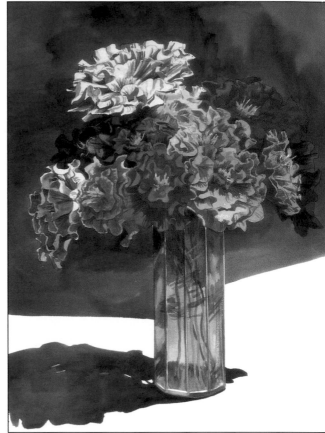

Step 7
Darken and enhance the vase with more Lemon Yellow, Opera, Cerulean Blue, Emerald Green, Raw Sienna, Alizarin Brown Madder and Cobalt Blue. Remember, you should be able to see the cast shadow through the vase.

Step 8
Paint shadows on the building and on the ground behind the vase and flowers using a wash of Cobalt Blue, French Ultramarine, Cobalt Turquoise and Cerulean Blue. Add Alizarin Brown Madder to balance all this blue.

Step 9
Continue working on the shadows with these colors, adding touches of Opera and Raw Sienna for warmth. Suggest the horizontal board pattern. Use masking tape for even edges.

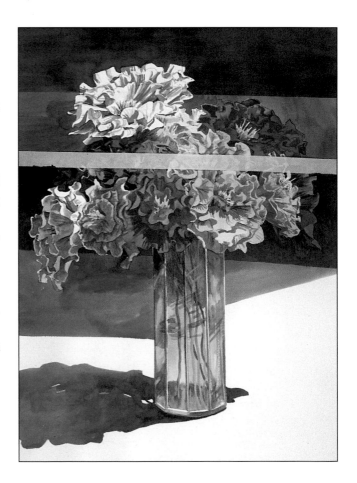

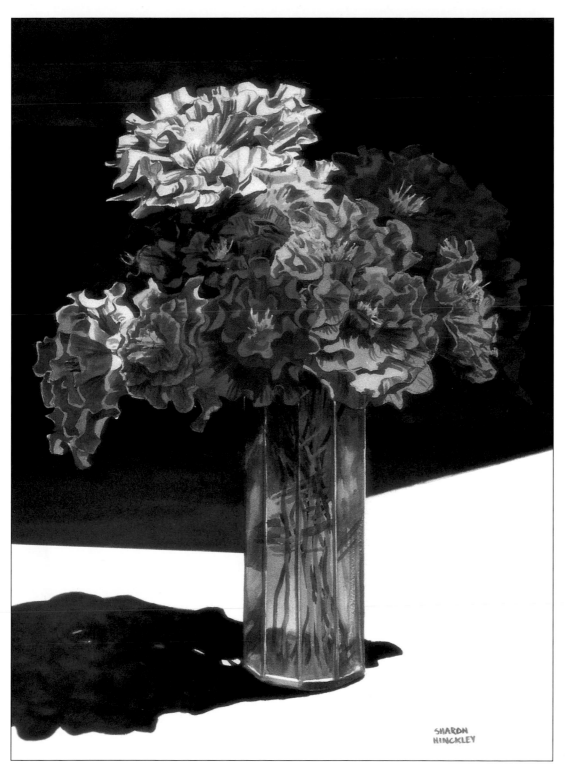

Step 10

Finally, paint more stems using Emerald Green, New Gamboge and
Cobalt Turquoise for the lighter stems and Cobalt Blue, French Ul-
tramarine and Alizarin Brown Madder for the darker stems.

Tropical Flowers: Calla Lilies

Originally from South Africa, calla lilies love to grow by water. The outer flower looks and feels like soft, creamy white paper wrapped around a yellow-orange spike, called a spadix. As the blossom opens, the white "paper" unrolls. They are big flowers with large leaves, so I suggest using plenty of paper and large brushes!

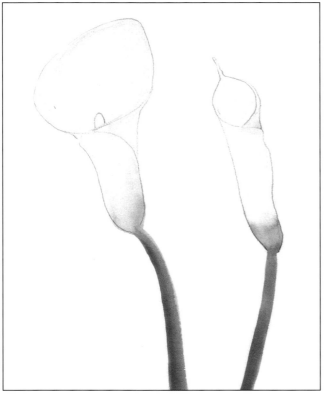

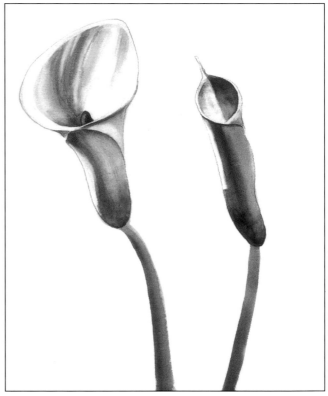

Step 1
Draw the lilies and their stems. Use washes of Lemon Yellow, New Gamboge and Opera to tint the flowers. Use Lemon Yellow, New Gamboge, Emerald Green, Cobalt Turquoise and Cobalt Blue for the stems.

Step 2
Paint flower and stem shadow shapes with Alizarin Brown Madder, Cerulean Blue and Cobalt Blue. This mix can be warmed with yellows or Raw Sienna, or it can be darkened and cooled with French Ultramarine.

Step 3
Using the standard "leaf soup" mix, paint three large leaves to serve as a background. For maximum contrast, place the darkest leaf behind the lightest flower.

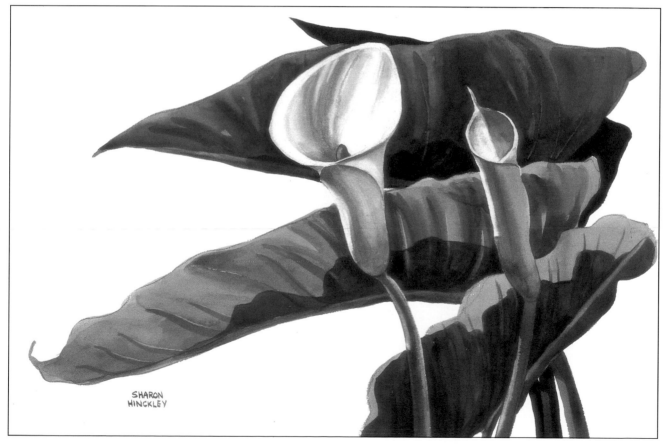

Step 4
Finally, add some French Ultramarine and Alizarin Brown Madder to the "leaf soup" mix to paint the dark shadows on the leaves and stems. Notice how our big lily touches the edge of the leaf? Paint another darker leaf in the background to improve the composition by removing the contiguous edge and bringing the lily into sharper focus.

Tropical Flowers: Hibiscus

The hibiscus, which means "delicate beauty," is the state flower of Hawaii. Its large, showy blossoms come in warm reds, pinks, oranges and yellows. The flower is like a circle divided into five petals, with long, slender stamens in the center. The petals flop about, creating wonderful opportunities to play with light and shadow.

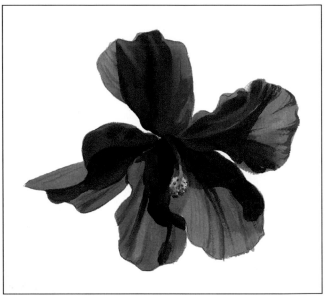

Step 1
Draw the outer shape of the larger flower and apply a varied wash of Scarlet Lake, Opera and New Gamboge across the petals. Some areas will be more red or more pink. Let your eye guide you in these choices.

Step 2
Paint the shadow shapes on the petals with Scarlet Lake, Opera, Cobalt Blue and Alizarin Crimson. Be aware of color temperature. Some shadow edges are cooler (bluer), while other areas are warmer (redder) with reflected light. Again, trust your eye.

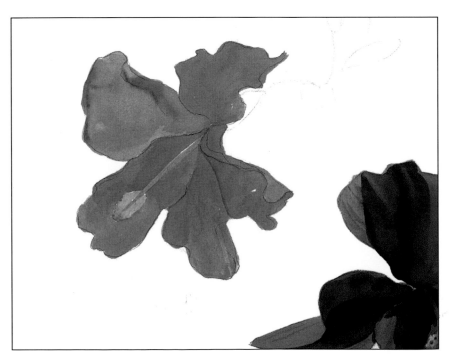

Step 3
Paint the second flower with Scarlet Lake, Opera and New Gamboge, but use a slightly different combination of the colors to obtain a softer effect.

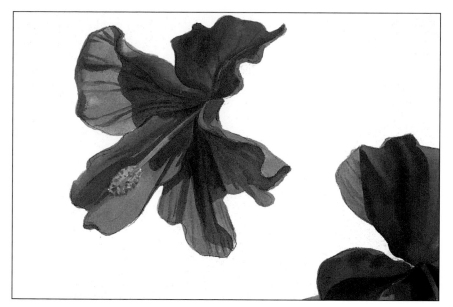

Step 4
Paint the shadows on flower number two with Scarlet Lake, Alizarin Crimson, Cobalt Blue and Cerulean Blue. Use Raw Sienna, Scarlet Lake and Cobalt Blue for the stamen.

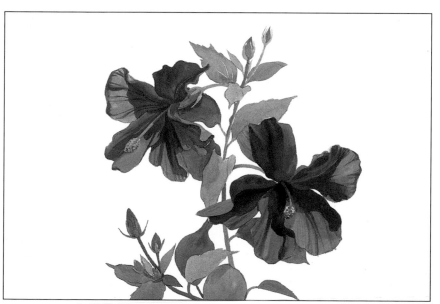

Step 5
Paint the leaves using Lemon Yellow, New Gamboge, Cobalt Turquoise and Cerulean Blue. Occasionally, neutralize this mix with touches of Opera, Scarlet Lake or Alizarin Crimson. Pay attention to the shape, position and angle of the leaves.

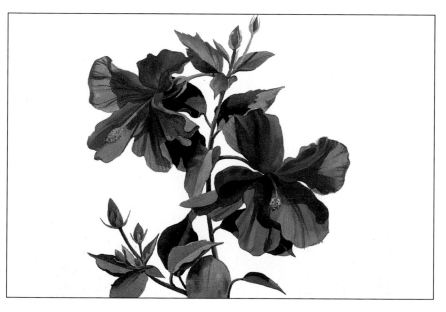

Step 6
Add the final darks and shadows to the leaves using our trusty "leaf soup" mix. Let your eye show you where it needs to be lighter, darker, warmer or cooler.

Tropical Flowers: Ginger

Ginger grows well in moist, shady places and produces red, white and pink flowers. A versatile plant, ginger is used as a cooking and healing herb—there's even a wild type in Hawaii that produces a natural shampoo!

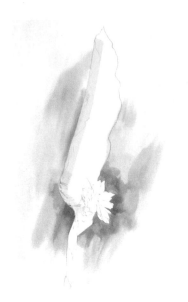

Step 1

Draw the flower, stalk and large leaf. Use masking tape to protect the edge of the leaf, and apply a wash of Lemon Yellow, Opera, Alizarin Crimson, Emerald Green and Cobalt Turquoise to create a soft background.

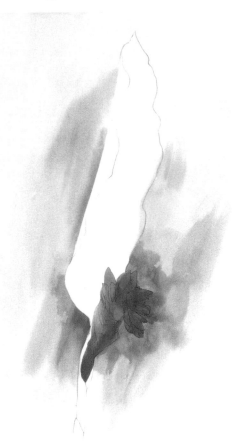

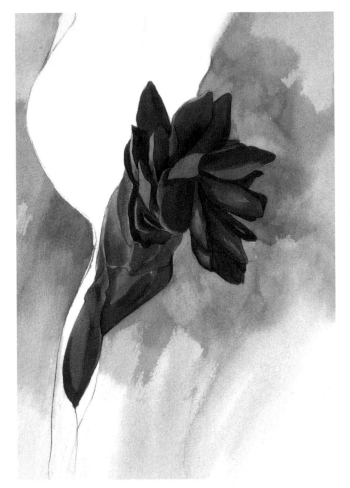

Step 2

Wash the flower petals with varying combinations of Opera, Alizarin Crimson and Cerulean Blue.

Step 3

Apply secondary washes to the petals using Opera, Alizarin Crimson, Cerulean Blue and Scarlet Lake. Let the colors of the flowers guide your placement of the paint.

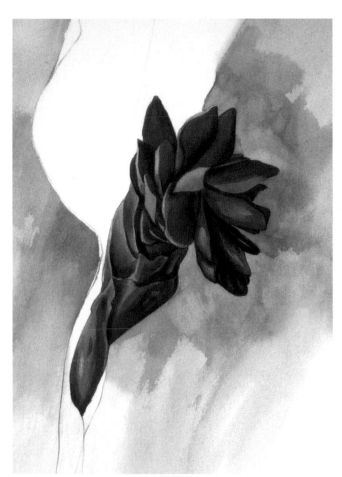

Step 4

Add a little Cobalt Blue and French Ultramarine to this mix and paint the final blossom details. With a clean brush and clear water, lighten the tops of a few petals. You might even use an X-Acto craft knife to scrape off a little more color first, but your paper must be completely dry.

Step 5

Wash the large leaf with Lemon Yellow, New Gamboge, Cobalt Turquoise, Cobalt Blue, Antwerp Blue and a touch of Emerald Green.

Step 6

Using the same colors, further define the leaf. Add two more leaves that are bluish in color and lighter in value to serve as a transition between the subject and the background. As a final touch, warm up your foreground wash with a little Opera and Lemon Yellow.

Popular Garden Flowers: Roses I

In this exercise we'll be painting dark shapes (two rosebuds—one tightly closed and the other just beginning to open) over a light background. Be sure to pay attention to the long stems and the angle of the leaves.

Step 1

Use a no. 2 pencil to make a light drawing of the subject. Apply a light background wash of Lemon Yellow, New Gamboge, Cobalt Blue, Cerulean Blue, Cobalt Turquoise and Emerald Green.

Step 2

Paint the basic leaf shapes and shadows mixing greens from the previous step plus Opera for a muted effect. Substitute French Ultramarine for Opera to achieve a darker color. Paint the small bud with a mixture of Opera and Alizarin Crimson. For the larger bud, use a little Scarlet Lake to warm up the mixture, add variety and bring the flower forward.

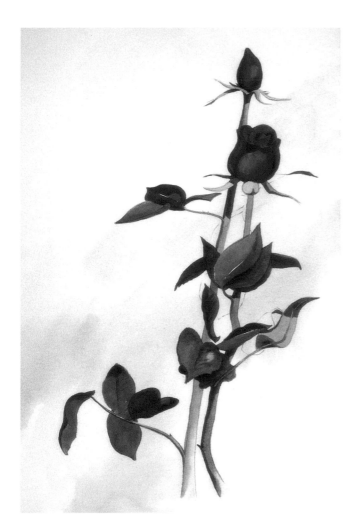

Step 3

Work more Opera and Alizarin Crimson into the small bud; add French Ultramarine to bring out the form. Give more depth to the large bud by adding French Ultramarine to your mixture of Opera, Alizarin Crimson and Scarlet Lake. Use touches of Cadmium Orange for variety. Paint the leaves with the "green leaf soup" mixture from step one, using more Lemon Yellow to cool some areas and more New Gamboge to warm other areas. Add Opera to the mixture for the warm, brownish pink undersides of the leaves, and add French Ultramarine and Cobalt Blue to deepen the shadows.

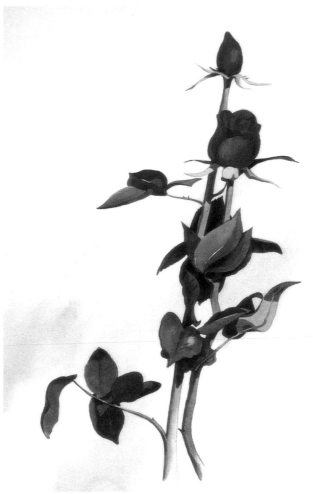

Step 4

It's not necessary to add any new colors to the painting at this stage. Simply strengthen and refine what you have already painted.

Popular Garden Flowers: Daylilies

A daylily is not a true lily, but a hardier version of that near relative. Daylilies need little attention and thrive almost anywhere. Although the flowers bloom for only one day, there are enough blossoms on each stalk to provide an abundance of color during their peak blooming period. Each flower opens into a six-petaled star around the long central stamens.

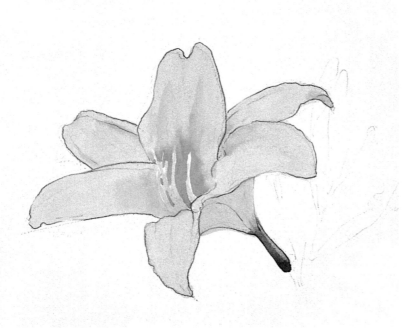

Step 1
Draw the open lily first and wash in the Lemon Yellow and New Gamboge, warming and cooling as needed. Use New Gamboge, Emerald Green and Cobalt Turquoise for the stem.

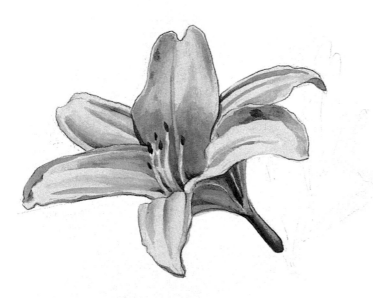

Step 2
Paint the pattern of light over the basic petal wash with a mixture of Emerald Green, Lemon Yellow, New Gamboge and Opera.

Step 3
Paint the stems and unopened buds with the usual "lcaf soup" mix.

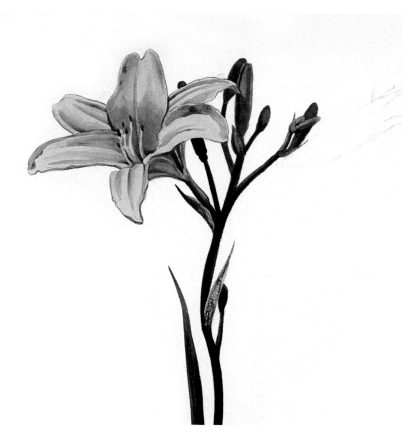

Step 4
Render the faded lily with a first wash of Lemon Yellow, New Gamboge, Opera and Winsor Violet. Paint the shadow shapes with Emerald Green, Cobalt Turquoise, Antwerp Blue, Winsor Violet, Raw Sienna and Alizarin Brown Madder. The multiple-brush technique would work well here.

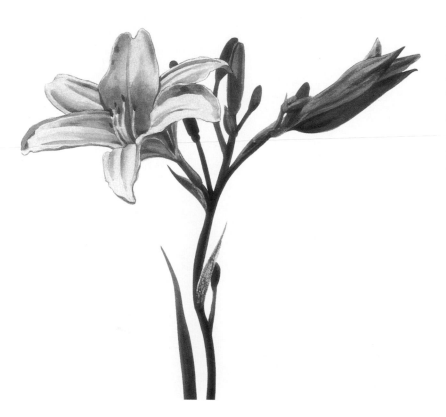

Popular Garden Flowers: Morning Glories

Morning glories, which are symbolic of affection, can often be seen climbing over trellises, fences and walls. Often a backdrop for other flowers, they are enchanting enough to stand on their own. Morning glory blossoms are basically circles broken into five arcs. The flower's body is cylindrical; each leaf is a trinity, with one large triangle flanked by two smaller ones.

We're going to try something different this time to see how well we're doing together. I'm listing my color mixes at the beginning of the demonstration instead of in each step to see how well you've picked up on my color theory. Remember to experiment and add to these colors as you like. Good luck!

"Leaf Soup": New Gamboge, Cobalt Turquoise with Lemon Yellow, Cerulean Blue, Cobalt Blue where needed.

Leaf Darks: the above with French Ultramarine and some "palette soup."

Morning Glories: Opera, Cerulean Blue and Cobalt Blue.

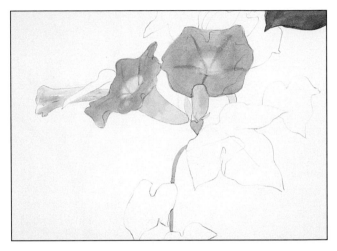

Step 1
Draw the blossom and leaf shapes, and paint the basic flower shapes, the vine and the upper-right leaf.

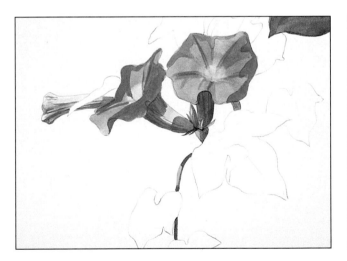

Step 2
Now paint the cast shadows on the blossoms.

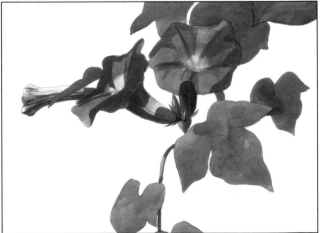

Step 3
Complete the pattern of light on the blossoms and begin to paint the leaf shapes.

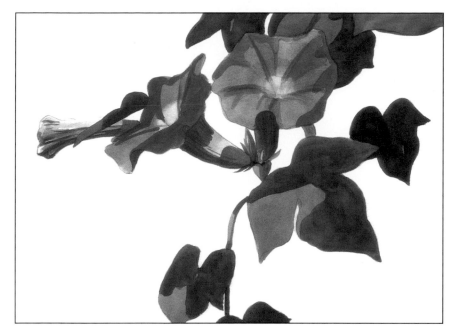

Step 4
Paint the shadow patterns on the leaf shapes.

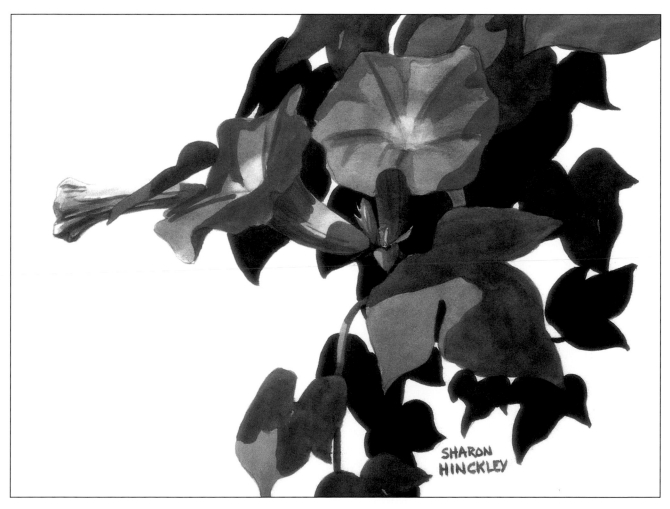

Step 5
To complete the painting, add some dark leaf shapes to unify the composition and support the morning glory blossoms.

Popular Garden Flowers: Roses II

This time we are painting a partially opened bud and a blossom well on its way to maturity. Ferns have been added for interest, but we'll be focusing more closely on the flowers themselves. As we progress, we'll also do some negative painting, or bringing out a shape by painting a darker color around it.

Step 1
Draw the rose and major leaf shapes. With New Gamboge, Opera, Cobalt Blue, Cobalt Turquoise and Cerulean Blue, apply a light wet-into-wet wash to suggest background interest.

Step 2
Paint the rose shapes using Alizarin Crimson, Scarlet Lake, Opera and a touch of Cadmium Orange for excitement.

Step 3
Define the blossoms with the multiple-brush technique. Load one brush with Opera, another with Alizarin Crimson, a third with Scarlet Lake, another with clear water and a final one with French Ultramarine (to deepen your shadows). Pay attention to the soft edges created by light and cast shadow.

Step 4
Soften the background colors with a wash of Opera and Alizarin Crimson. Continue painting the ferns with a New Gamboge, Cobalt Blue, Cobalt Turquoise and French Ultramarine "leaf soup." Paint the rose leaves with the same soup, enriching the mixture with Scarlet Lake and Emerald Green.

Step 5
Add some dark fern shapes to the lower-left foreground. Use New Gamboge, Scarlet Lake and French Ultramarine for a nice, rich, green-black color. These shapes create a pleasing sense of asymmetrical balance.

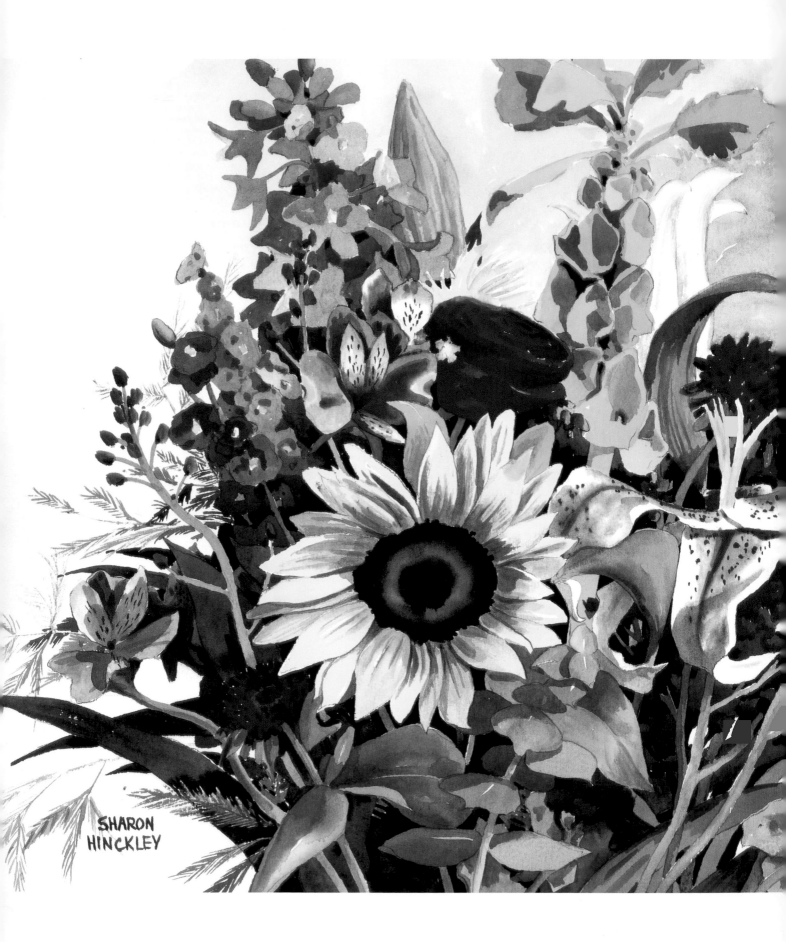

PAINTING FLOWER ARRANGEMENTS

There are many different styles of flower arranging, from the lush European-style bouquets to the classic simplicity of a Japanese *ikebana*.

In this chapter we'll begin by painting a fairly simple subject and progress to projects of increasing complexity. Actually, we'll paint the first subject twice, each time under a different light source. Light—its temperature, intensity and direction—is an important influence on any painting and demands close attention.

Now let's lay out our brushes, moisten our paints and let the fun begin!

Beautiful Bouquet
14″×21″ (36cm×53cm)

Two Carnations in a Bottle I

Our main focus for this simple arrangement will be not so much the subject itself, but its lighting. Throughout this book I have been talking about light: its quality, color, direction and the mood it sets. This painting and the next will illustrate the possibilities presented by different lighting conditions. Therefore our subject is simple: two carnations—one red, one pink—in a small bottle of water.

This painting was done in my studio, where the subject was illuminated by a single floodlight. The light source is warm and the bottle is bluish green. The effect is similar to what you might encounter painting outdoors on a sunny day.

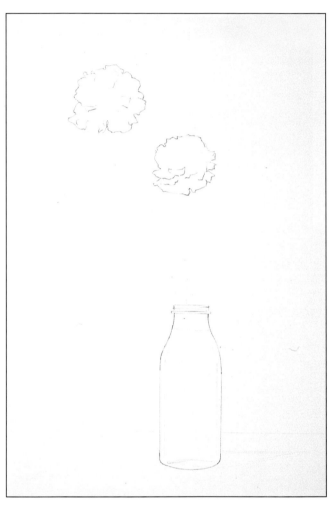

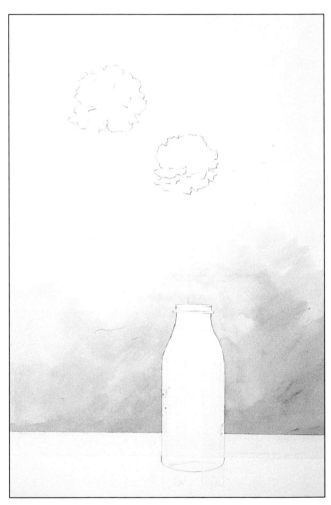

Step 1
Carefully draw the outer shape of the carnations and the bottle. Only suggest the placement of the stems.

Step 2
Use masking tape to protect the edges of the bottle and table. Starting at the top of your painting and working down, apply a background wash. Begin with Lemon Yellow and add a little Opera. Introduce Raw Sienna and, just above the table edge, Cobalt Blue. (Somehow my brush picked up a touch of Warm Sepia. I decided it was a happy accident and chose to go with it.)

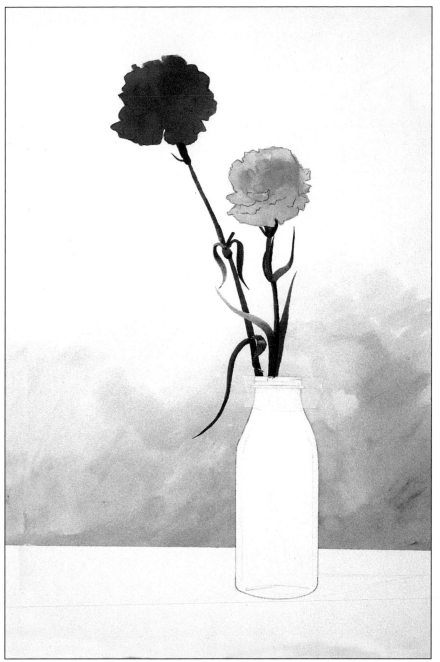

Step 3

Remove the masking tape and check for leaks, which can be removed with a little clean water. Paint the flower shapes using Opera and Lemon Yellow for the pink carnation and Scarlet Lake, Opera and New Gamboge for the red carnation. Mask the top of the bottle with tape. Paint the stems with a basic "leaf soup" of New Gamboge, Cobalt Turquoise, Cobalt Blue and Opera. Finish the stems above the bottle at this stage. If you need to darken your soup, add French Ultramarine.

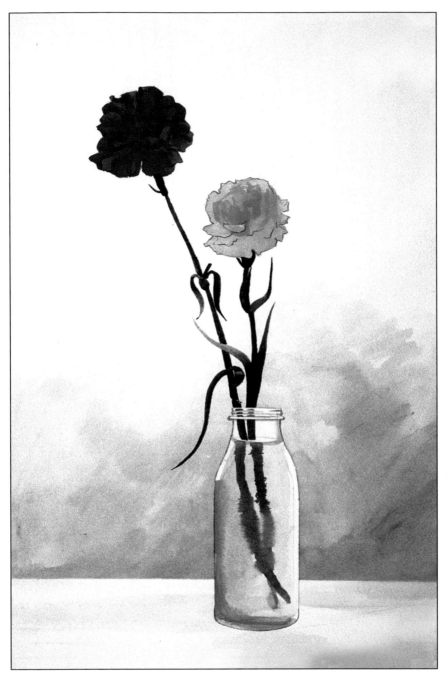

Step 4
Soften the table edge with a bit of clear water. Tone the stark white table with a wash of Lemon Yellow, Opera, Cerulean Blue and Cobalt Blue. Add more Opera, toned down with a little Lemon Yellow, to the pink carnation. Create more petal shapes on the red carnation with Alizarin Crimson. Paint the stems above the water level with "leaf soup"—since the glass is clear, the stems should be the same color as those in step 2. Work wet-into-wet below the water level to show how light refraction distorts the stems.

Step 5 ▶
Paint the final shadows on the red carnation with Alizarin Crimson, French Ultramarine and Winsor Violet. Use Opera, Lemon Yellow, Alizarin Brown Madder (for warmth) and Cerulean Blue on the pink carnation to create a purplish hue. Apply a final wash to the bottle using Cobalt Blue and Cerulean Blue. Use Lemon Yellow and Raw Sienna to portray the reflected light at the bottom. Paint the bottle's shadow with Opera, Cobalt Blue and Cerulean Blue. Be careful to leave the light magnified through the water into the center of the shadow.

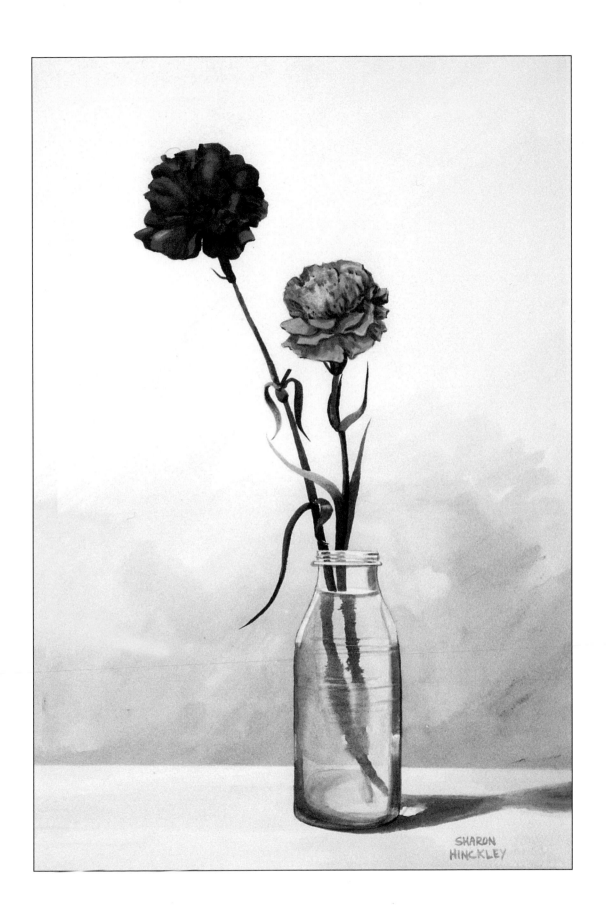

Two Carnations in a Bottle II

This painting was also done in my studio, but on a cloudy morning with a high overhead ceiling light almost directly over the flowers. The effect was very similar to what you might encounter painting outdoors on a cloudy day.

Step 1

As with the previous painting, carefully draw the flowers and bottle. Make light pencil lines to indicate the stems. For the first table wash, combine the warmth of Opera with Lemon Yellow and Cerulean Blue. Paint soft shadows with Lemon Yellow, Opera, Cerulean Blue, Cobalt Blue and Alizarin Brown Madder. Use masking tape to define the edge. We want cool colors for the wall, so start at the top with Cerulean Blue. As you work downward, add Cobalt Blue, a touch of Emerald Green and, finally, French Ultramarine at the very bottom.

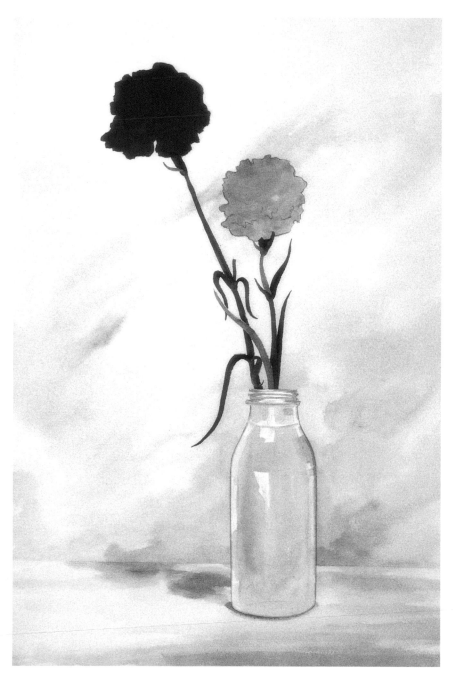

Step 2

Paint the basic flower shapes. Carnations are basically circles with squiggly edges. Use Scarlet Lake and Alizarin Crimson for the red flower and Opera and Lemon Yellow for the pink flower. Use a "leaf soup" of New Gamboge, Cerulean Blue, Cobalt Turquoise, Cobalt Blue, Opera and French Ultramarine to paint the stems. Add a little Alizarin Brown Madder to the mix to paint the water in the bottle, but not the bottle itself.

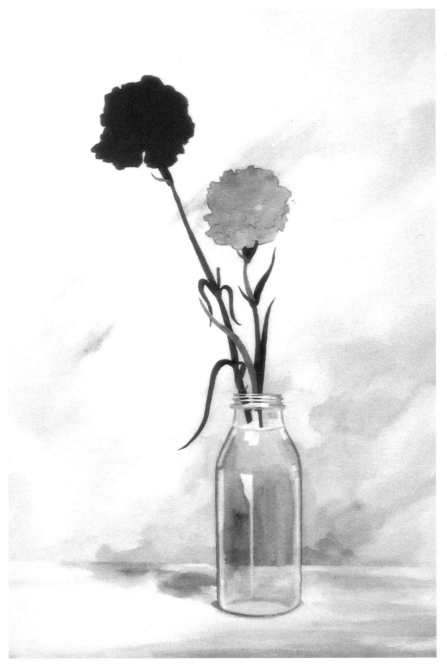

Step 3
Continue working on the water in the bottle. Because the water is clear, it is defined by the shapes and colors of the materials in and around it.

Step 4 ▶
Use more "leaf soup" to paint the tops of the stems above the water, then work wet-into-wet to indicate the stems in the water. To finish, bring out the red carnation with Opera, Alizarin Crimson and French Ultramarine. Bring out the pink carnation with Lemon Yellow, Winsor Violet, Cerulean Blue, Alizarin Brown Madder and a touch of Scarlet Lake.

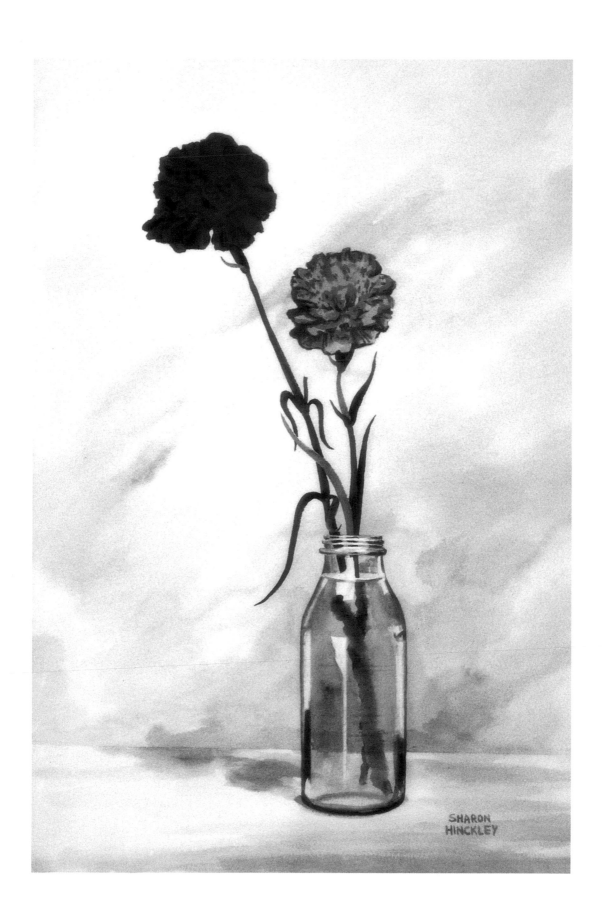

Miniature Bouquet in a Blue Vase

One sure way to lift your spirits is to focus on painting a cheerful bouquet of flowers. Even a few flowers will have a positive effect. Our bouquet consists of carnations, two kinds of chrysanthe-mums, statice and a wispy, dark green tree fern. The blue vase is for contrast.

This painting was done in my dining room next to a window wall facing north.

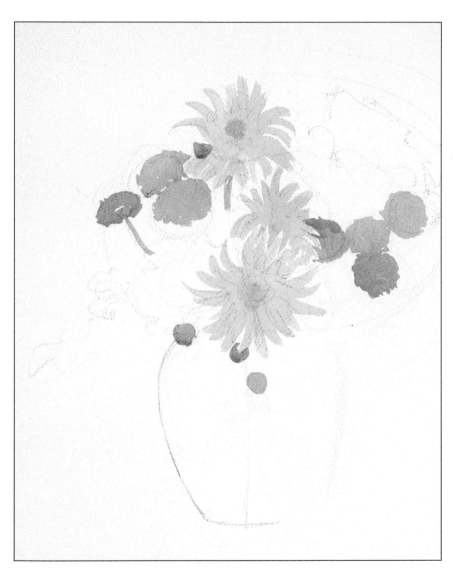

Step 1
Lightly draw the basic shapes. Paint the yellow flowers first because they're the lightest, brightest part of the composition. Use Lemon Yellow, New Gamboge and Emerald Green for the larger cushion chrysanthe-mum. For the button mums use New Gamboge, Opera, Cadmium Orange, Raw Sienna, Lemon Yellow and Emerald Green.

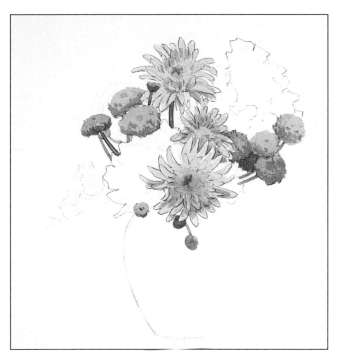

Step 2
Continue using the pigments from step 1 to give more definition to the chrysanthemums. Paint a few of the stems with Emerald Green, New Gamboge and Cerulean Blue.

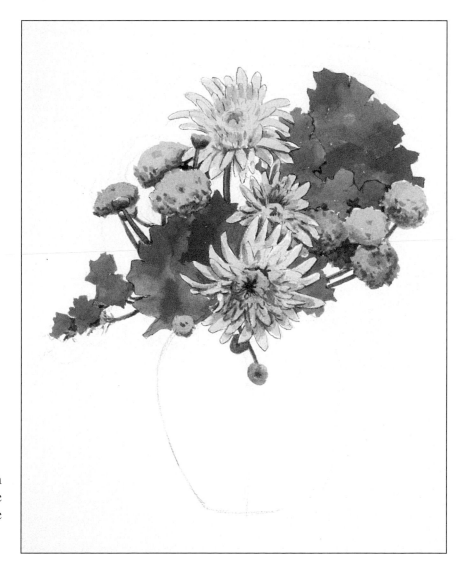

Step 3
Paint the red carnations using Scarlet Lake and Opera. For the statice use Opera, Cobalt Blue and Cerulean Blue. Add more stems. Continue to define the cushion mum by adding a touch of Alizarin Brown Madder to the colors used in step 1. Darken the cushion mum's center with a wash of Emerald Green.

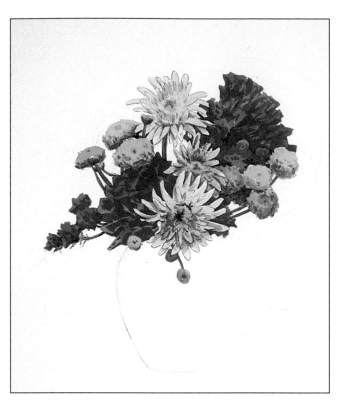

Step 4
Begin painting the shading on the carnations and statice. For the carnations, use Opera, Alizarin Crimson and Scarlet Lake; for the statice, Cobalt Blue, Opera and Cerulean Blue.

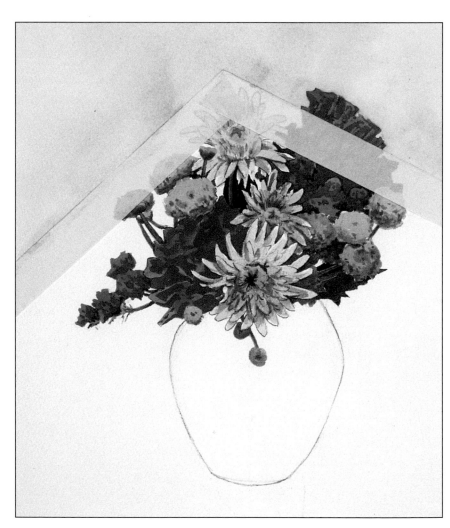

Step 5
Draw the vase and a few leaves. To suggest the presence of a white table, mask the edge with tape and, with great abandon, apply a background wash of Alizarin Brown Madder, Cobalt Blue and Cerulean Blue.

How to Draw a Symmetrical Vase

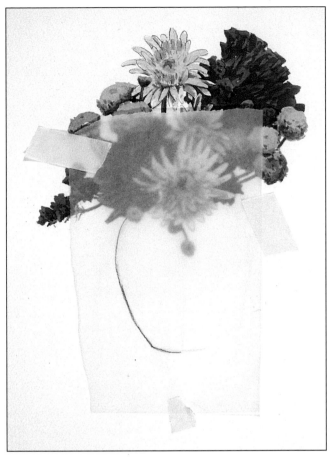

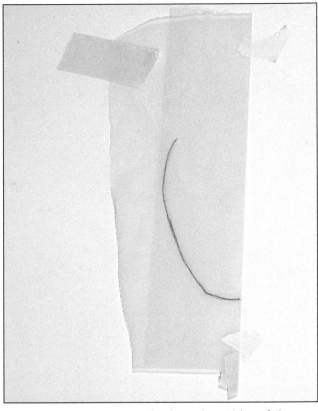

Draw half of the vase as accurately as possible. Take a piece of tracing paper and trace this half of the vase.

Fold the tracing paper exactly where the mid-line of the vase would be. Now retrace the first half.

Unfold the tracing paper and use a soft no. 2 pencil to retrace the entire vase. This soft line will act as your carbon. Lay the tracing paper over your vase, placing the carbon side down. Using your regular pencil, draw over the entire outline of the vase. Voilà! Perfect symmetry every time.

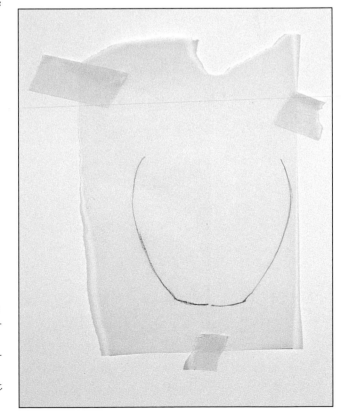

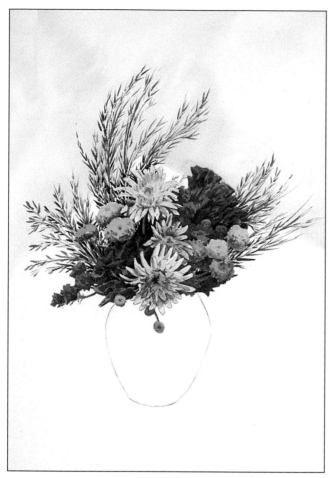

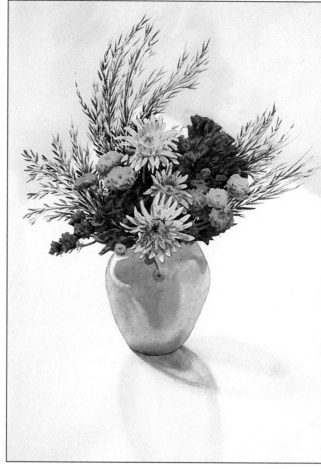

Step 6
We don't want a hard edge here, so remove the tape and soften the edges with a tissue and a brush moistened with clear water. Paint the wispy tree fern leaves with a "wispy leaf soup" mix consisting of touches of Lemon Yellow, New Gamboge, Cerulean Blue and Cobalt Blue. Add touches of Cobalt Blue and French Ultramarine for additional flavor. Also, paint some shading on the carnations with Alizarin Crimson, French Ultramarine and Scarlet Lake.

Step 7
Now we'll work on the blue vase. First, paint the double shadow with Cerulean Blue, French Ultramarine, Alizarin Brown Madder and a touch of Opera. Then apply the first washes to the vase with French Ultramarine and Cerulean Blue.

Step 8
Leave a white highlight on the left side of the vase. Use "leaf soup" to paint the underwater stems and leaves. Use Cerulean Blue and French Ultramarine to suggest the pattern on the vase. Notice how the water level inside the glass appears lighter on the left and darker on the right. For a final touch, lighten the stem on the yellow button mum hanging over the center of the vase; this will bring the bud into sharper focus.

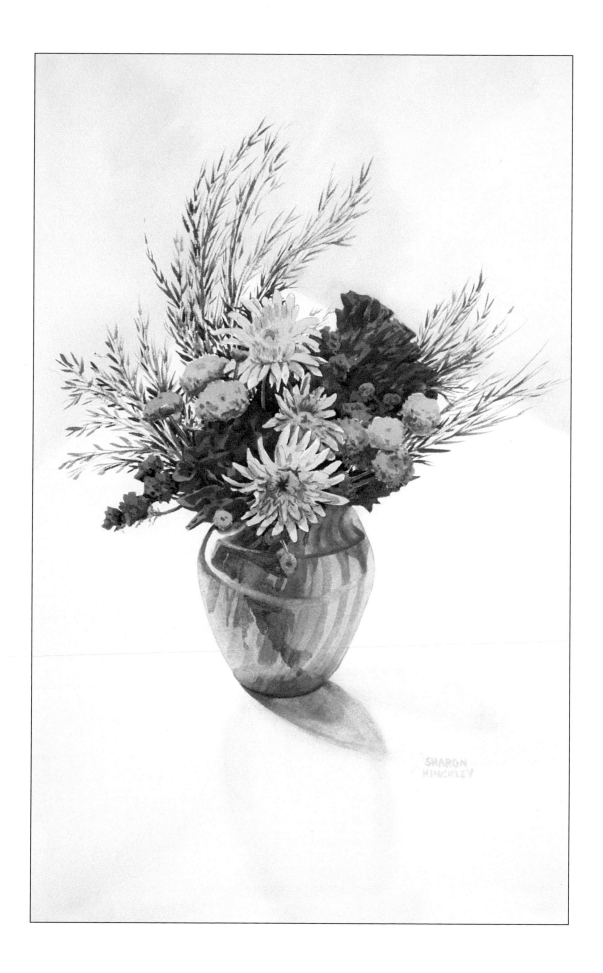

Ikebana

Ikebana is the Japanese art of flower arrangement. The study of *ikebana* goes far beyond the placement of flowers in a container. It includes, but is not limited to, the study of nature, aesthetics, philosophy and spirituality. While Japanese flower arrangements may appear simple, they are the result of extensive practice and study to achieve delicate harmony and balance.

Japanese floral arrangements consist of three major elements, referred to as "heaven," "man" and "earth." In *sogetsu*, the *ikebana* style we'll be painting, they are called *shin*, *soe* and *hikai*. *Shin* is the tallest and establishes the arrangement's character. *Soe*, the next tallest, supports or reinforces the *shin*. The shorter *hikai* complements and balances the *shin* and *soe*. Any other element is only there to enhance and reinforce the three main pieces.

Our *shin* and *soe* are blue magic irises and our *hikai* is a pink Acapulco lily. Lemon leaves support the lily and curly willow supports the irises.

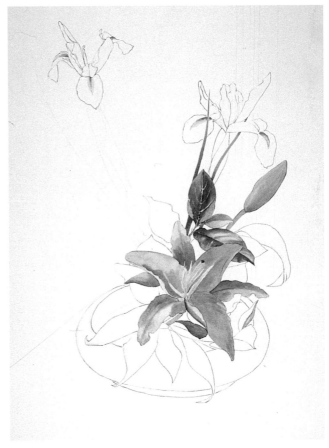

Step 1

Draw the foreground elements—the lily, lemon leaves and white bowl. When you draw the bowl, remember to use the tracing paper technique you learned in the previous painting. Use touches of Lemon Yellow and Emerald Green for the stamens and "leaf soup" for the first leaves.

Step 2

Begin painting the petals of the Acapulco lily with a generous amount of Opera and dashes of Lemon Yellow, Cerulean Blue and Scarlet Lake. Add some Emerald Green to the center. Work on the lemon leaves with Lemon Yellow, New Gamboge, Cerulean Blue, Cobalt Turquoise and Cobalt Blue. Paint the yellow marks on the Blue Magic iris with Lemon Yellow, New Gamboge and Opera.

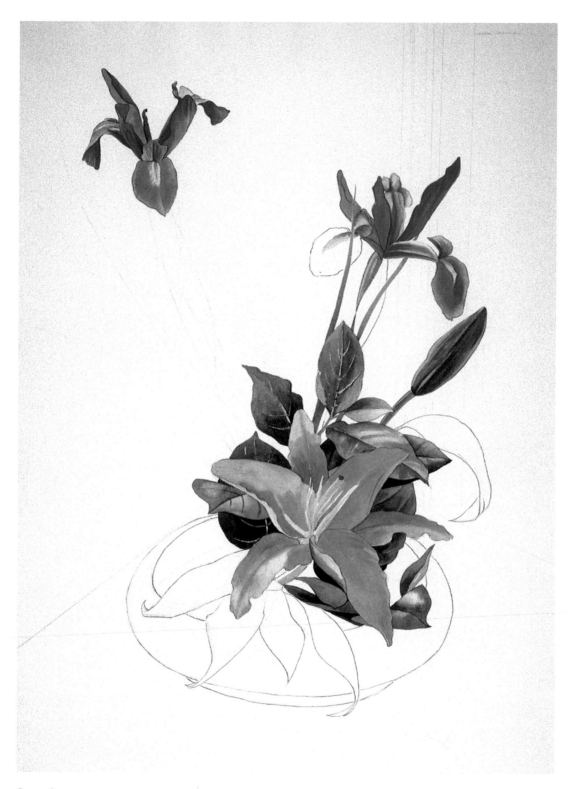

Step 3
Continue to develop the shape of the lemon leaves. Use Cobalt Blue,
Cerulean Blue and Opera to paint the Blue Magic iris.

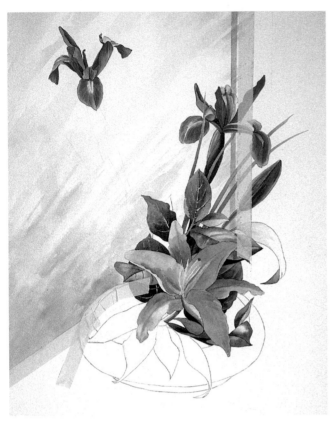

Step 4

Mask the edges of the table and wall with tape.
Mix lots of water with Alizarin Brown Madder,
Cobalt Blue and Cerulean Blue, and wash in a sug-
gestion of the window. While this wash is wet, add
small touches of Lemon Yellow, Emerald Green
and Opera near the edge of the bowl.

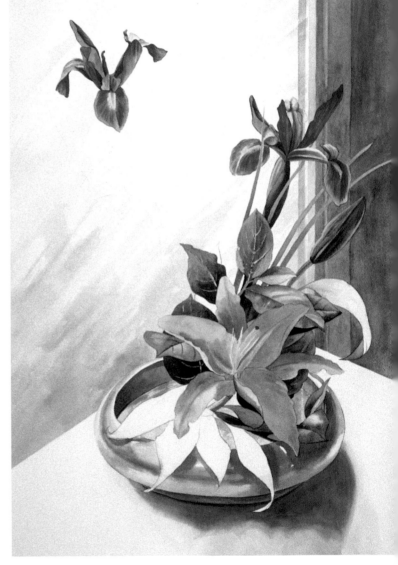

Step 5

Paint the bowl and wall shadows using Cerulean
Blue, Cobalt Blue, Alizarin Brown Madder and
touches of French Ultramarine and Raw Sienna.
The bluish shadow pattern under the bowl helps
define the bowl's shape.

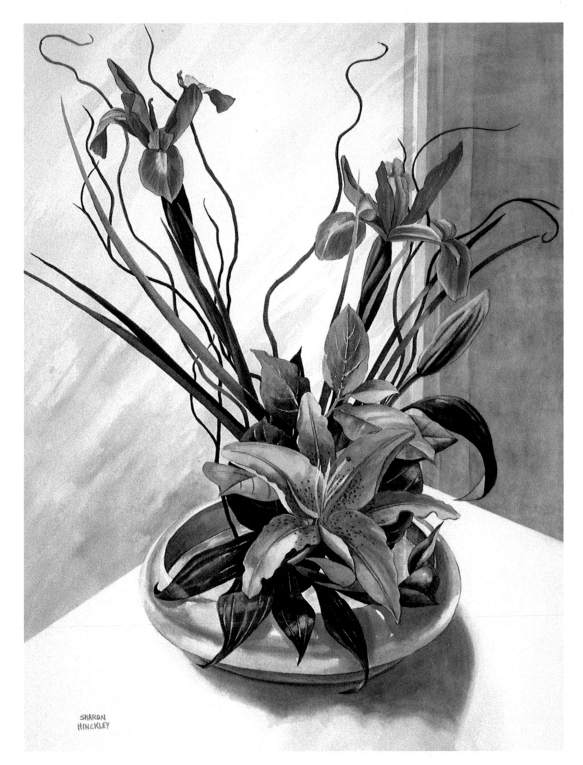

Step 6

Add French Ultramarine to your "leaf soup." Use this soup to paint the dark foreground leaves and to darken other leaves that you have already painted. Lighten the lily bud by lifting some color with a clean brush charged with clear water. Also, soften the edge of the table with a clean brush and clear water. Likewise, soften the wall color and add touches of Opera, Lemon Yellow and Cerulean Blue. Paint the curly willow with Alizarin Brown Madder, Cobalt Blue and Raw Sienna.

Be My Valentine

When I received this special bouquet from my husband, I had to drop everything to paint it. There is a lot of complexity in the flowers and leaves, and wonderful contrast in the red, white and pink flowers. Because the subject was so complex, I deliberately chose a light source that would be easy to work with: diffuse overhead light.

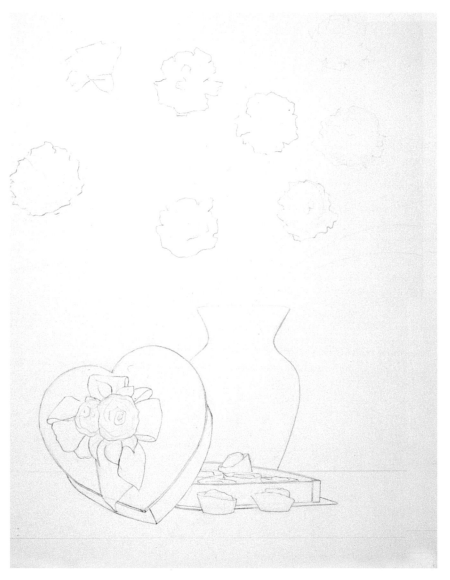

Step 1
Carefully make a basic pencil drawing of the vase, candy box, candy and carnations.

Important Masking Tips
Don't try to use rubber cement or liquid frisket in direct sunlight or under a hot light. The result will be a sticky goop that will gum up your paper and be impossible to remove. It's best to use old brushes coated with soap to apply rubber cement and frisket. Apply liquid frisket with a toothpick or a knife when you want a thin line instead of a round dot.

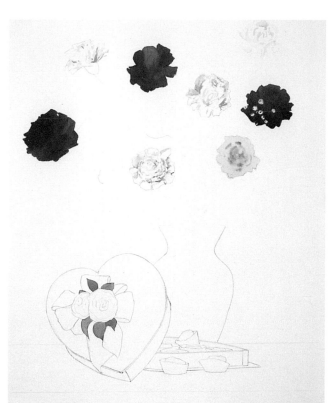

Step 2

Mask the baby's breath blooms with frisket, masking tape or rubber cement, which is what I'm using here. Once your masking is dry, paint the carnation shapes. Lightly tint the white flowers with a blush of Lemon Yellow and Opera (add a little New Gamboge to the foreground flower). Our goal is for every flower to be slightly different in color and shape. Paint the red carnations with Scarlet Lake, Cadmium Orange and Alizarin Crimson. Use Opera, Lemon Yellow and New Gamboge for the pink carnation. When the white flower is dry, shade it with Cerulean Blue, Alizarin Crimson and Scarlet Lake to define the petal shapes. Paint the leaves on the candy box with Emerald Green, Lemon Yellow and New Gamboge.

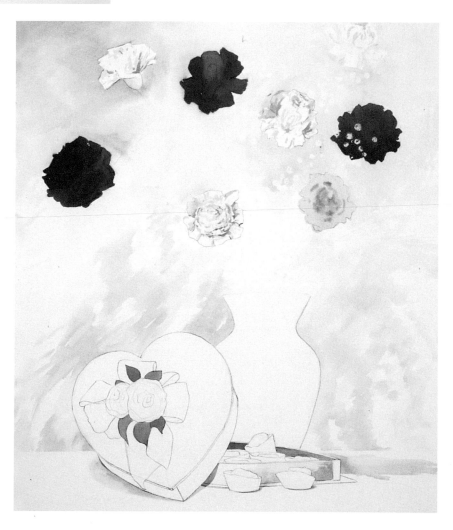

Step 3

Use a mixture of cool colors—Cerulean Blue, Cobalt Blue and French Ultramarine—to paint the light shadows on the wall. Use this mixture to paint the shadowy side of the table and the shadows on the candy box. Use Alizarin Brown Madder for the red reflection on the candy box.

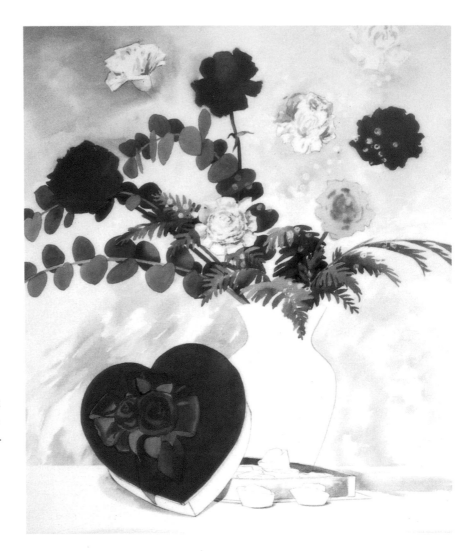

Step 4
Work on the ferns and stems with the "leaf soup" mix. Paint the eucalyptus leaves with Emerald Green, Opera, Lemon Yellow, Cobalt Turquoise and Cobalt Blue. Try to show a lot of variety in these leaves. Think contrast—warm vs. cool, light vs. dark.

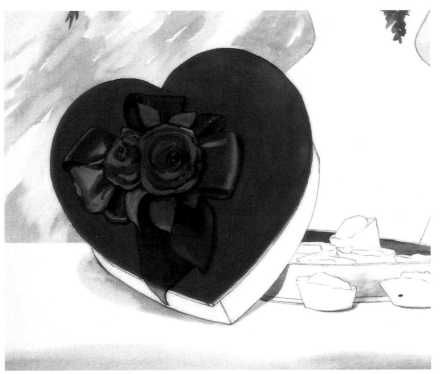

Step 5
Now paint the heart-shaped candy box lid with lots of Opera, Alizarin Crimson and Scarlet Lake.

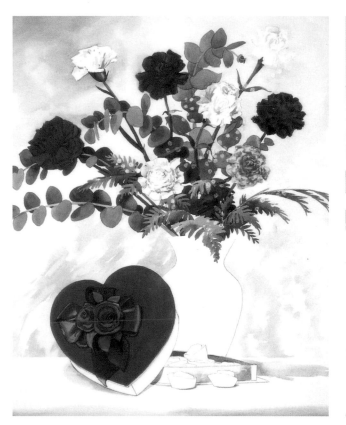

Step 6
Continue to work on the leaves and stems, using the same colors as in step 5.

Step 7
Finish the leaves and stems. Follow the model closely but allow yourself the freedom to move a stem up or down, to add some things and to omit others entirely if it serves your purpose. With a subject this complex, it isn't necessary to paint every leaf and stem to get your point across.

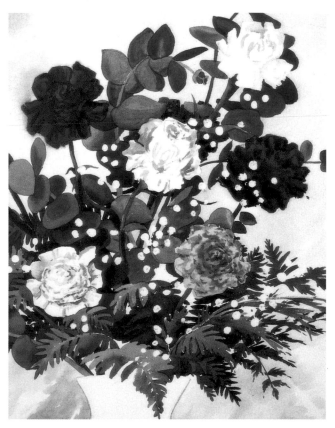

Step 8
Remove the masking from the baby's breath.

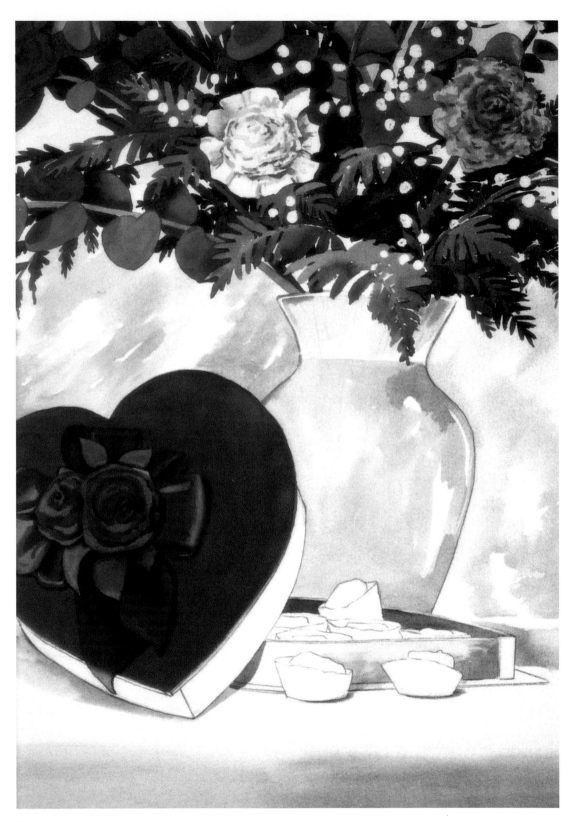

Step 9

Now it's time to paint the water in the vase. Remembering that water takes on the color of its surroundings, be careful to leave some highlights on the glass. We'll rely on our trusty "leaf soup" mix for all the nuances of color we'll need.

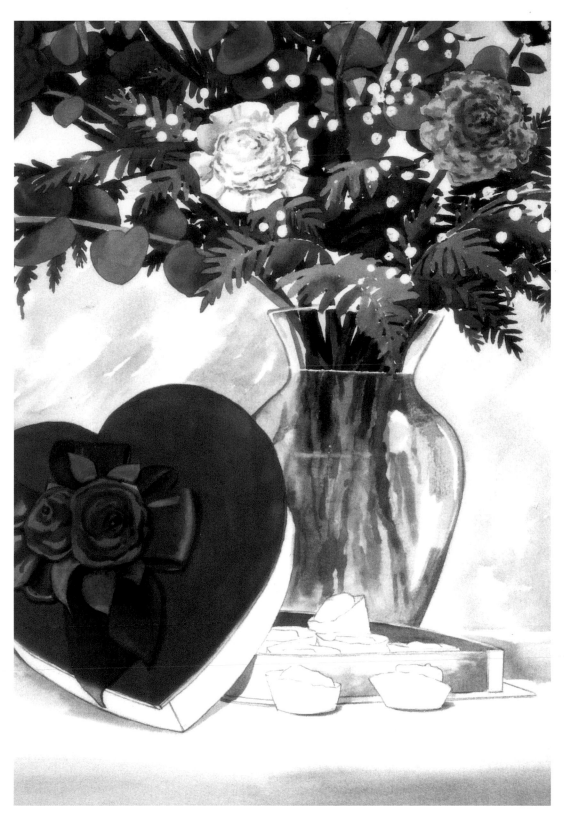

Step 10
Paint the stems above and below the water line. As with *Carnations in a Bottle*, work the underwater stems wet-into-wet.

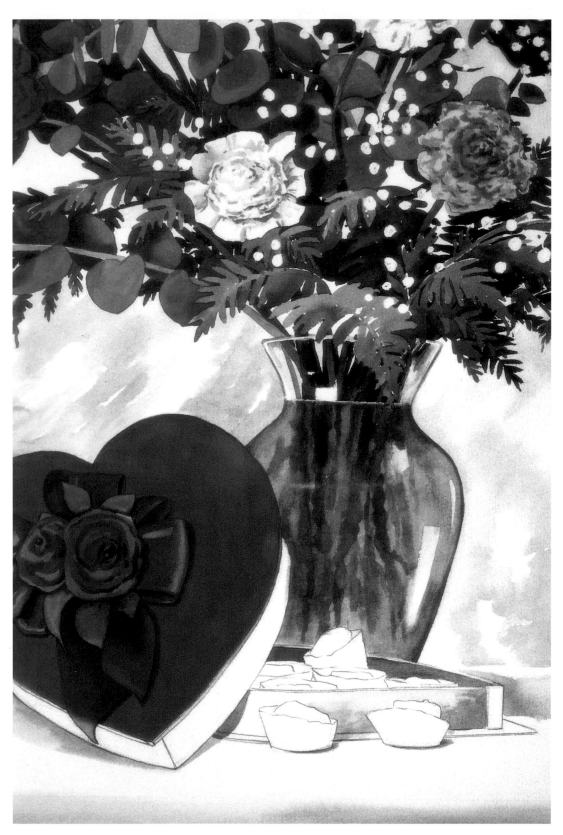

Step 11
Darken the water to enhance the overall effect of
the painting. Also, lift up and strengthen a few
more reflections on the vase.

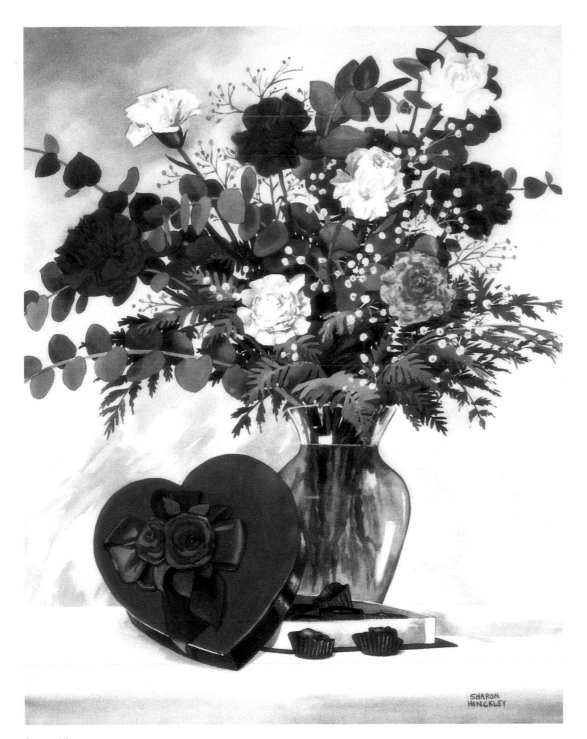

Step 12

Tint some of the baby's-breath blossoms with Lemon Yellow, Opera and Cerulean Blue. Use this mixture to paint the darker baby's-breath toward the top and sides of the bouquet. When necessary, add a little Cobalt Blue and Alizarin Brown Madder for depth. To complete your valentine, paint the candy, the candy wrappers and the sides of the heart-shaped lid. Now tell the truth—which did you finish first, the painting or the candy?

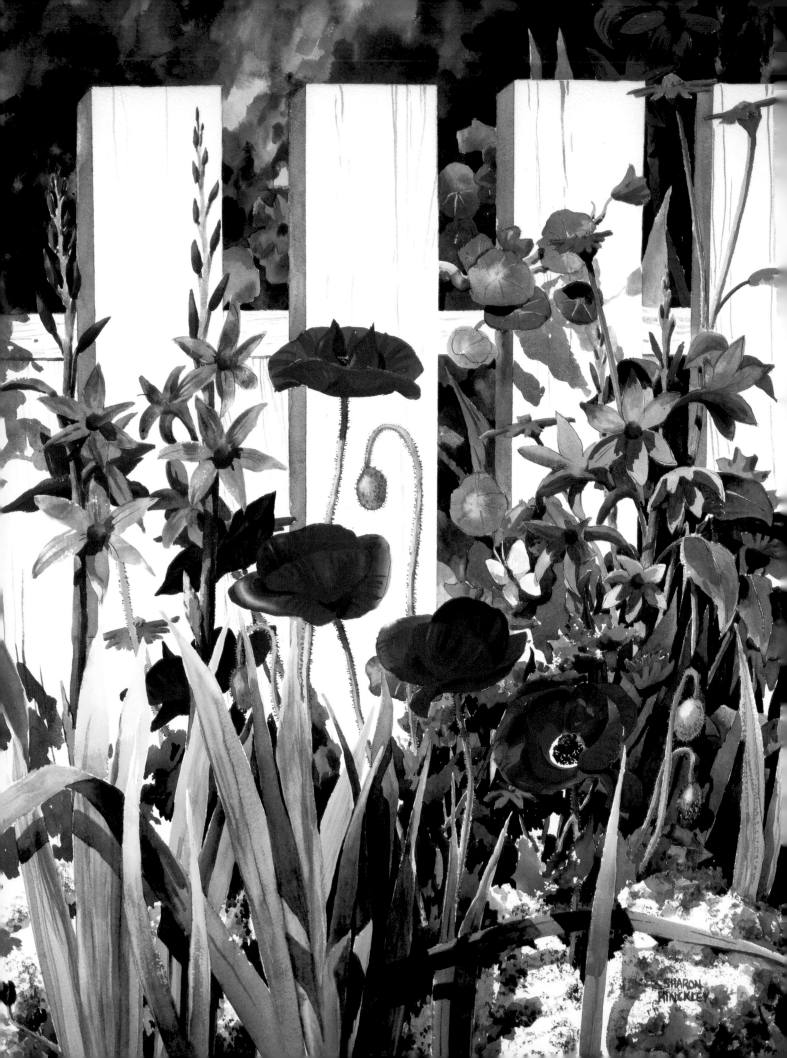

PAINTING OUTDOORS

Working outdoors is my favorite part of painting! There's nothing like painting flowers with the dramatic contrasts between light and shadow on a bright, sunny day. It's a challenge to capture the translucent quality of flower petals when light is filtering through them.

I've also learned to appreciate the beauty and mystery of an overcast day. It's often appealing to paint flowers on a cloudy day because shape and color become the focus of the picture.

Many artists work from photographs, and excellent books have been written about creating art from photography. While I love photography and am not opposed to technology (at the moment I'm working on a high-powered computer and loving it), I do not paint this way. Photos are wonderful study aids, but even the most advanced camera cannot record color with the precision and clarity of the human eye. The camera may be faster, but when it comes to subtlety and sensitivity, I trust myself every time.

Joyful Flowers
25" × 19" (64cm × 48cm)

Bird-of-Paradise

San Diego is the perfect place for a floral artist. The climate is mild and it's possible to paint outdoors almost every day. The temperate weather is ideal for many kinds of flowers, including the tropical flowers. Walking in the city park I noticed a bird-of-paradise growing by the art museum. Originally from South Africa, the bird-of-paradise is a striking flower. The orange blossoms do indeed look like a tropical bird! One advantage to painting outdoors is listening to real birds singing while you work. Can you hear them now?

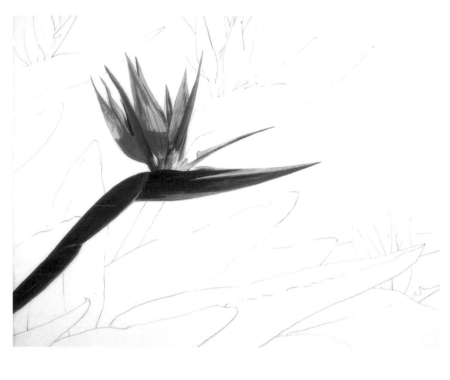

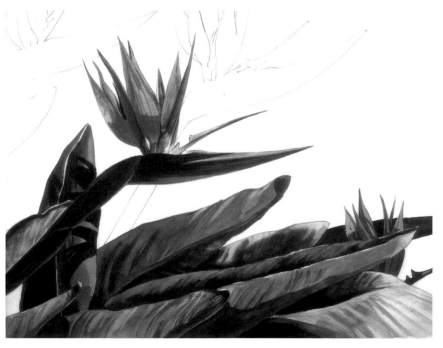

Step 1

Begin with a light pencil drawing of the basic shapes. Remember the four-quadrant grid? We'll create our focal point by placing the main blossom in the upper-left with its stem reaching up through the bottom-left and along the center line, into the right. To paint the blossom, mix New Gamboge with Opera for a vibrant orange, dotting a little more yellow here and there. Add Alizarin Brown Madder to create depth. For the stem, use a standard soup mix starting with New Gamboge and Cobalt Turquoise. Use plenty of Cobalt Blue and Alizarin Brown Madder to model the rounded shape.

Step 2

Begin painting the foreground leaves and lower-right blossom. Continue with the "leaf soup" mix for the foliage. The leaves are warmer on the inside, so add a little Raw Sienna to portray this.

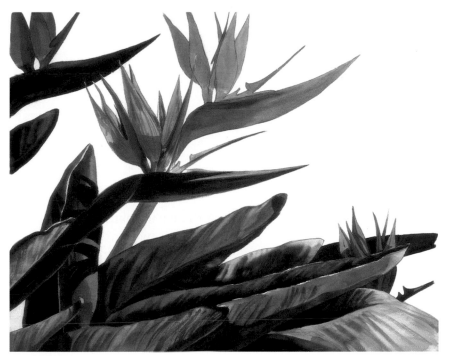

Step 3

For the upper-center and left-hand blossoms, continue to use New Gamboge, Opera and Alizarin Brown Madder, but in different proportions. We don't want any two blossoms to appear exactly alike. Remember, there should be both unity of color *and* variety.

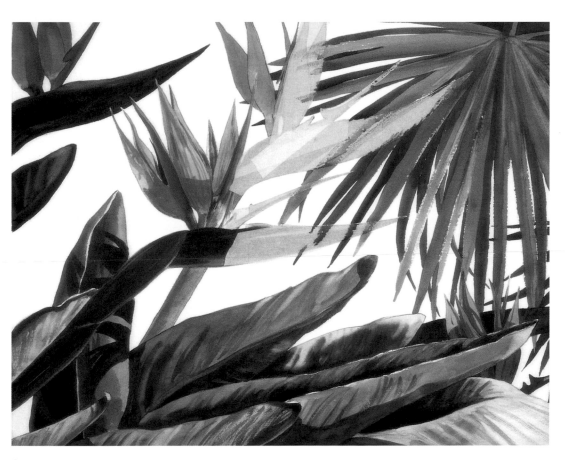

Step 4

Since bird-of-paradise flowers tend to grow in one direction, counter this by brushing in some palm fronds. Use masking tape for the edges you wish to keep sharp. You should have a generous amount of "palette soup" going now, so add some Cerulean Blue and Opera to paint the grayish blue areas of the palm fronds.

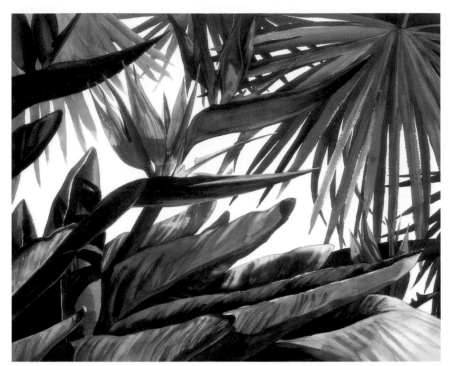

Step 5

Adjust your "palette soup" to add a warmer palm frond in the upper-left corner and a cooler frond behind the upper-center blossom. We can also paint another background leaf beneath our center of interest. Remove the masking tape and use the "palette soup" to complete the stem and leaf of the upper-center flower. Remember to include a little reflected blossom color along the leaf's upper edge.

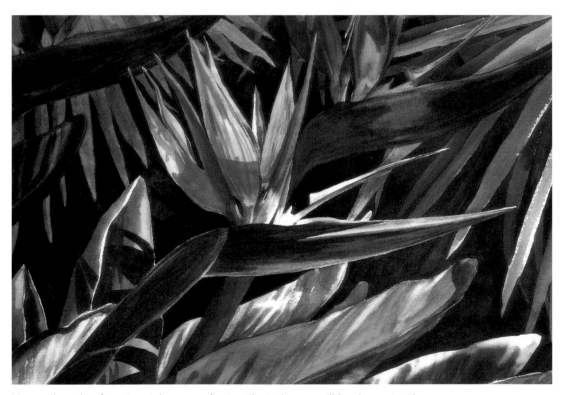

Honor the rule of contrast by remembering that the eye will be drawn to the area where the darkest dark and the lightest light meet. Our main blossom should be in that area. The black color next to this brightest orange blossom is really just a mixture of whatever pigments were darkest on my palette.

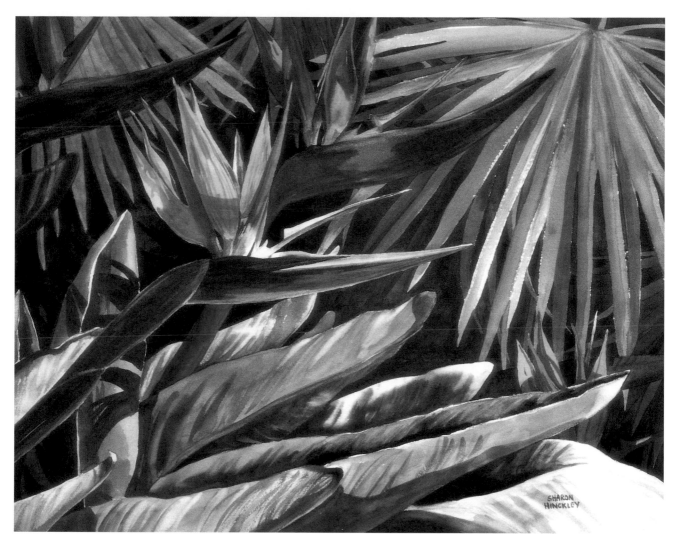

Step 6
Finally, paint the darkest background area, suggesting a few palm
fronds in the process.

Golden Lilies

While painting *Bird-of-Paradise*, I noticed a marvelous group of golden daylilies a few yards away. It was late afternoon and the sun, almost directly to my right, was moving lower in the sky. The lilies were dancing in this pattern of light. One flower stood out in full sunlight—the perfect center of interest. The remaining lilies were in shadow, making an excellent background. I was struck by the rhythmic dance of light and shadow across the flowers. Golden rays of sunlight glimmered along the edges of the background flowers. I chose a vertical format to emphasize the height and movement of these graceful flowers.

Step 1

We'll paint our center of interest in the lower-left quadrant with a basic color of New Gamboge, with additions of Raw Sienna and Alizarin Brown Madder. Surround this blossom with tall, slender lily buds. Use a basic "leaf soup" for the buds. Add extra New Gamboge and Raw Sienna for the nearly open bud.

Step 2

Now begin work on the supporting blossoms, focusing on the upward rhythmic movement of the lilies and their affection for the sun as they gently lean towards the light. Continue using New Gamboge with liberal additions of Raw Sienna. Add touches of Alizarin Brown Madder and even a bit of Winsor Violet. We want to be sure these flowers remain behind our focal point.

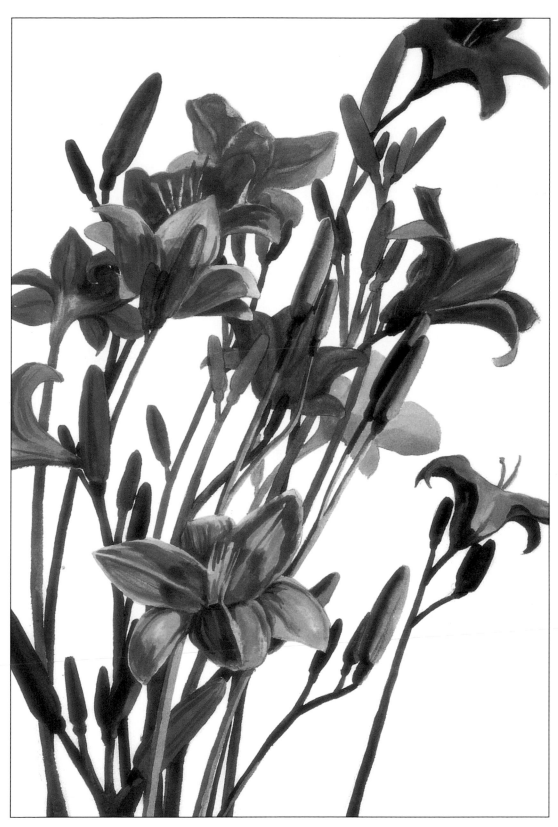

Step 3

Most of the lilies are in shadow, but a few catch rays of sunlight. As you move into the background, paint less and less detail on each flower. In fact, paint some merely as shapes and others with only two layers of wash.

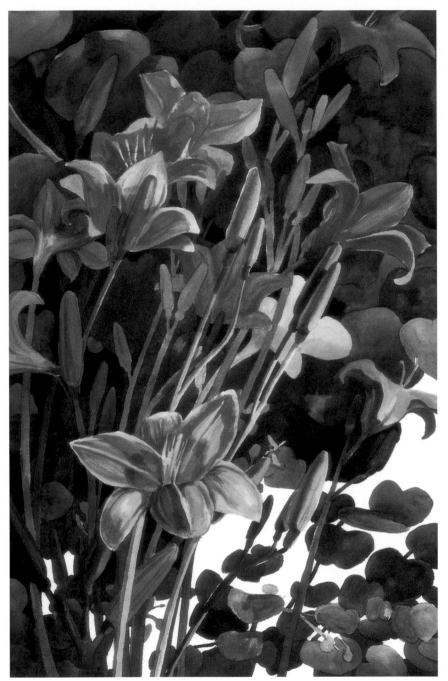

Step 4
Let's paint a dark background to emphasize the lilies' radiance. Dark leaves would be perfect. If necessary, move to a place where some trees and bushes are growing. Continue to use "leaf soup" with touches of Cobalt Blue, French Ultramarine and Alizarin Brown Madder for depth. For more color variety, mix Opera with Cerulean Blue.

Step 5 ▶
Add the final darks using more of the same pigments from step 4, and simplify some of the shapes you've already painted, if needed.

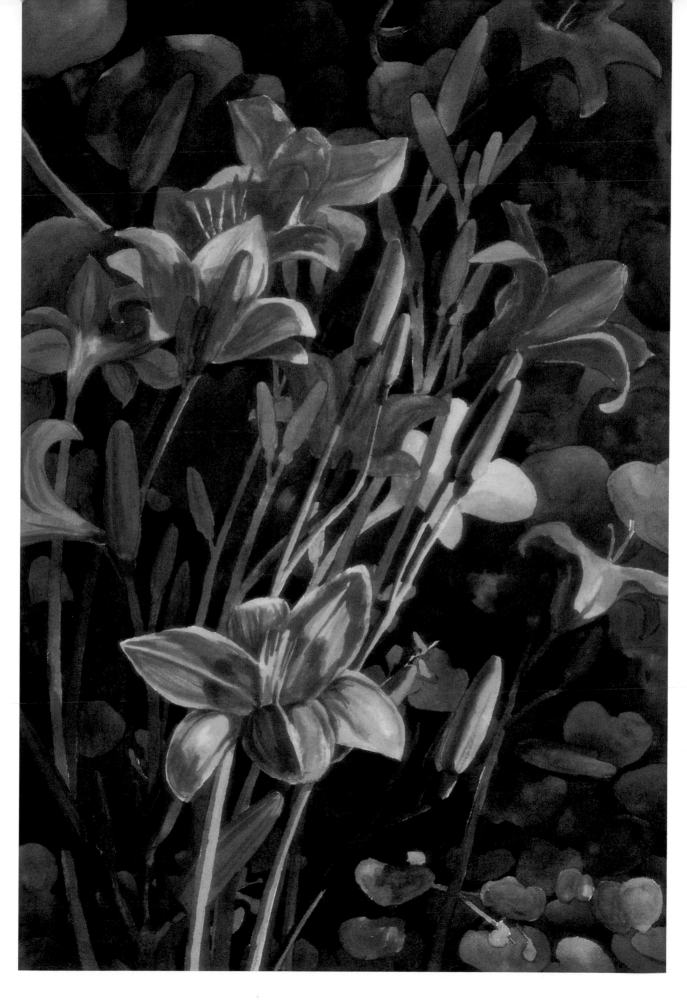

Cyclamen

The weather was iffy on the day I made this painting. While it never did rain, it didn't get very sunny, either. I was attracted to these flowers because of their particular shape and contrast with the surrounding foliage. Remembering the principle of keeping the lightest light, darkest dark and center of interest in the same place, I felt this was certain to be a successful painting. As with *Be My* *Valentine*, this was a simply illuminated but fairly complex subject. I sat under a veranda while a very soft, diffuse light filtered down, even in those few moments the sun showed her face.

We'll complete this painting in three easy steps: first the foreground, then the middle area and finally the background.

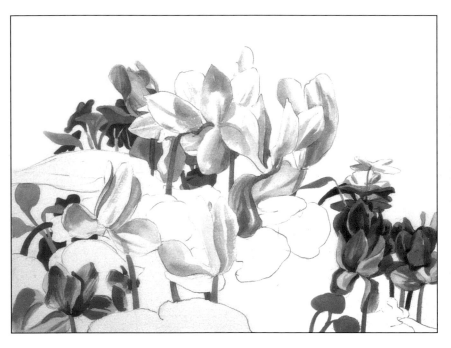

Step 1

Paint the white cyclamen first. Start with the colors and soft shadows of the flowers. Washes of Lemon Yellow and Opera will reveal the warmth of the petals. For shading, use a combination of Alizarin Brown Madder, Cerulean Blue and Cobalt Blue. These bluish purple washes will look very dark when you paint them in. However, when the painting is finished, they will appear to be almost too light in comparison with the dark background. This is exactly what we want.

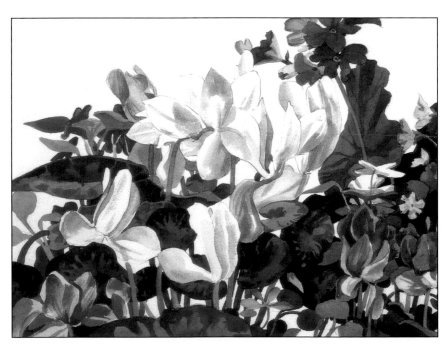

Step 2

Paint most of the leaves and the rest of the stems. Paint the red and white impatiens and the pink cyclamen, also. They are included to add variety and to give the painting an asymmetrical balance. For the pink cyclamen, use Opera toned down with a little Lemon Yellow. Use Scarlet Lake for the red impatiens. Use your trusty soup mix for the leaves.

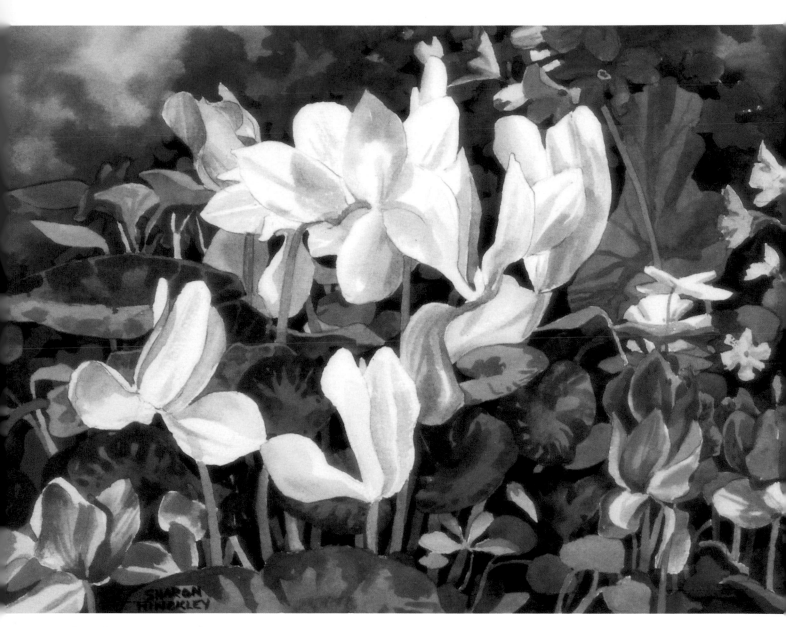

Step 3

Now we're ready to add the background and finish the painting. Carefully paint the primroses behind the cyclamen with Opera, Cerulean Blue and Cobalt Blue for your basic washes. In other areas paint wet-into-wet washes of "leaf soup" mix. Let the washes run into the primrose hues to suggest more flowers in the background. Now you're ready to stand back and make any corrections. I decided to tone down the impatiens leaves on the lefthand side of the painting to draw the eye back to the cyclamen. And there you have it. As easy as one, two, three!

Calla Lilies

As mentioned in the tropical flower section in chapter three, calla lilies are water-loving plants. Calla lilies symbolize "magnificent beauty."

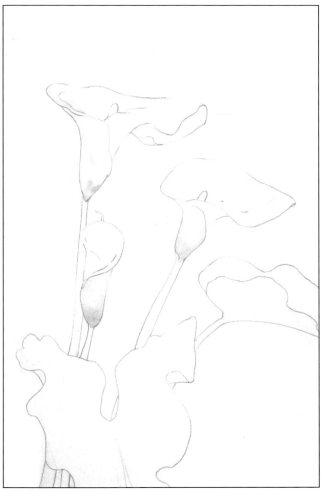

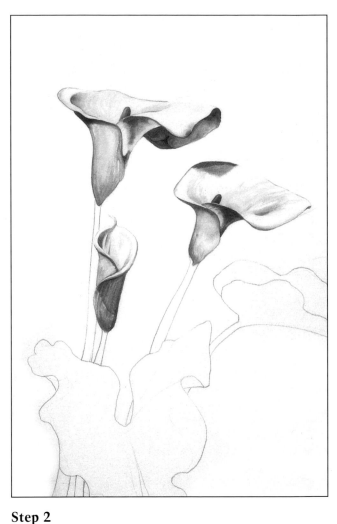

Step 1

Begin with a drawing of three lilies and two leaves. The callas are rather creamy in color. Put in some first washes with Lemon Yellow, New Gamboge, Emerald Green and a touch of Opera.

Step 2

The largest lily is a little more orange. The middle lily is more yellow. The smallest, most pure lily is white. Using Lemon Yellow, New Gamboge, Raw Sienna, Opera, Alizarin Brown Madder, Cerulean Blue, Cobalt Blue and Emerald Green, rely on your eye and constant comparison of one area of the painting to another to tell you which areas need to be warmer or cooler. The shadows are mostly Cerulean Blue, Cobalt Blue and Alizarin Brown Madder. On the blossom undersides, introduce Raw Sienna for warmth. Paint the orange flower spike peeking out of the center with New Gamboge and Opera. Use a touch of Lemon Yellow to highlight and a bit of Alizarin Brown Madder to shade.

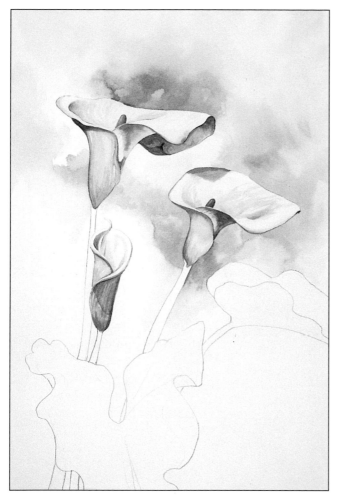

Step 3
Working wet-into-wet now, suggest some purplish flower shapes in the background with Opera, Winsor Violet and Cerulean Blue. I use three brushes: a big one with clean water to blend and soften; a smaller round brush with my purple color; and a flat brush with a "leaf soup" of Lemon Yellow, New Gamboge, Emerald Green and Cobalt Turquoise.

Step 4
Keep going with these background colors. You have two goals—see how much fun you can have and make sure you apply your colors uniformly behind the flowers and leaves.

Bringing Up a Painting
Raising a painting is a lot like raising a child. The most successful artists (parents) use an equal amount of love and discipline. At this stage a painting requires a lot of both! This is the painting's teenage period. It's easy at this point to look at your efforts and think, "What have I done! I wish I had never undertaken this venture."

What should you do when you reach this stage of desperation? Keep painting! All it means is that you have a half-grown painting on your hands, and it simply isn't finished yet.

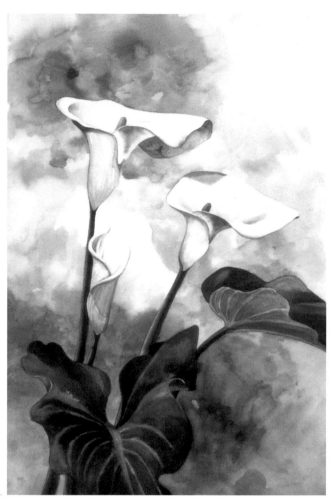 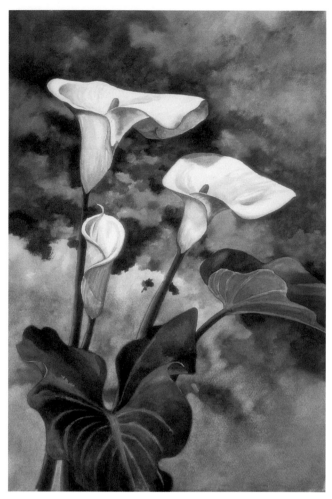

Step 5
Paint the stems and leaves, working carefully to capture the feeling of the leaves. Add some Cobalt Blue and Antwerp Blue to your basic soup mix for depth and rich color.

Step 6
Now work on the finishing touches. Constantly play back and forth; lift a little color in one spot, scrub in color in another area. This is a place where old, "broken" brushes are useful. You can even use an old credit card to scrape some texture into the wet paint.

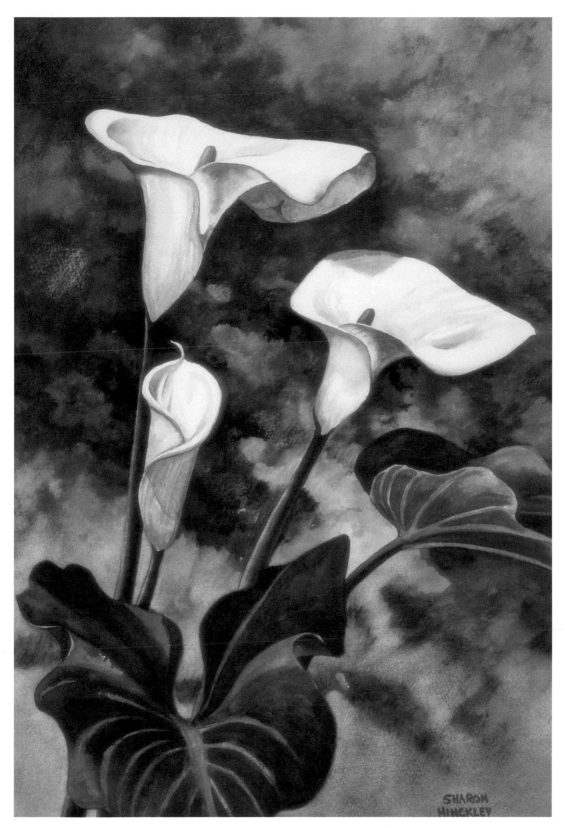

Step 7

Deepen and soften the area behind the large lily, and strengthen the darks of the leaves. Sign your name. Even when you think a painting is truly finished, stand back and take another look. Better yet, wait twenty-four hours before taking that final look.

Garden Scene

Remember that black-eyed Susan we painted in chapter three? I think it can be the focal point for an exciting painting. This one may take a little time because there are several other flowers we'll be adding to the background.

All of the flowers in this painting were growing in my garden. I simply needed to "transplant" a little to fit everything into one painting. I did this by working with the same angle of the sun at the same time each day for several days in a row.

Just for fun, we'll use a square format for this painting.

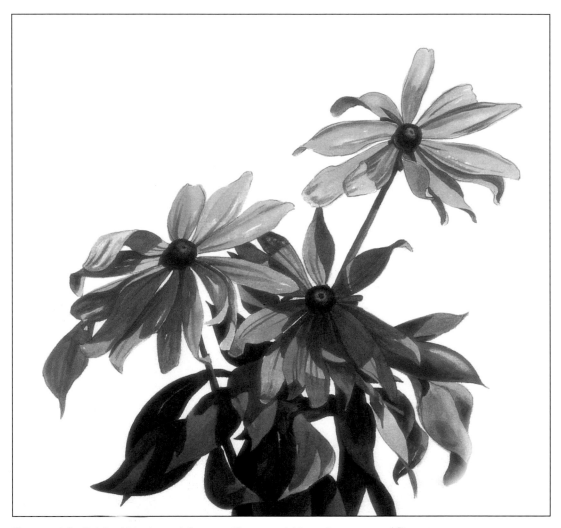

The partially finished black-eyed Susans. There could have been many different ways to complete this painting. We'll explore the choices I made.

Step 1

Begin by adding a yellow-orange lantana and red geraniums behind and above the Susans. Paint the lantana blossom with a New Gamboge and Opera mix and the leaves and stem with a basic "leaf soup" of Lemon Yellow, New Gamboge, Cobalt Turquoise and Cobalt Blue. Paint the geraniums with Scarlet Lake and small additions of Opera and New Gamboge.

Step 2

Continue adding geraniums. Add some purple nierembergia peeking from behind the Susans. Use Opera, Cerulean Blue and Cobalt Blue for the blossoms and a darker blend of "leaf soup" for the foliage.

Step 3
Add still more geraniums and leaves. To vary the color, apply some Alizarin Crimson and a touch or two of Cobalt Blue to the geranium on the left. Paint an undercoat for the flower pot with New Gamboge, Opera, Alizarin Brown Madder and a touch of Cerulean Blue.

Step 4
Now concentrate on the greens—some ferns, ficus leaves and the geranium leaves. Use a variety of pigments, including New Gamboge, Lemon Yellow, Raw Sienna, Emerald Green, Cobalt Turquoise, Cobalt Blue, Cerulean Blue, French Ultramarine and Alizarin Brown Madder— just a step or two away from "palette soup!"

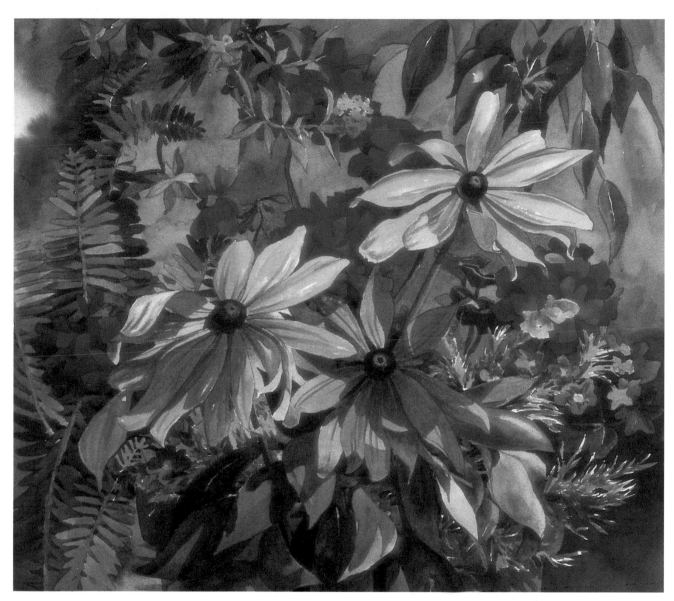

Step 5
Add a background wash of Cobalt Turquoise as a cool, greenish
contrast to the warm foreground flowers.

Step 6
Paint more ficus and fern leaves with a cool, dark "leaf soup" that includes Cobalt Turquoise and French Ultramarine. Also, darken two of the geraniums with a mix of Alizarin Crimson, French Ultramarine and Cobalt Blue.

Never Give Up!
While it can be easy to become discouraged during the process of creating a painting, my experience is that it's best to see a piece through to the end. Usually the frustration arises from having an incomplete painting. When a painting is completed, nine times out of ten the result will be most pleasing. And, if you are still dissatisfied, nothing is lost because you will have learned during the process!

Step 7

Paint the final darks, even mixing black in the areas around the black-eyed Susans for greater contrast. The painting seems a little top heavy, so finish by lightening just a few of the foreground leaves to balance the composition.

A Final Note

Thank you for joining me on this journey into the field of floral painting in watercolor. I have enjoyed your company on our excursion and I wish you every success in all of your painting endeavors. Remember, when you are starting any new project,

- Break the work down into pieces.
- Have fun!

INDEX